IMAGES
of America

CHINESE IN CHICAGO
1870–1945

IMAGES
of America

CHINESE IN CHICAGO
1870–1945

Editors Chuimei Ho and Soo Lon Moy for
the Chinatown Museum Foundation

ARCADIA
PUBLISHING

Copyright © 2005 by Chinatown Museum Foundation
ISBN 978-0-7385-3444-2

Published by Arcadia Publishing
Charleston, South Carolina

Printed in the United States of America

Library of Congress Catalog Card Number: 2005924981

For all general information contact Arcadia Publishing at:
Telephone 843-853-2070
Fax 843-853-0044
E-mail sales@arcadiapublishing.com
For customer service and orders:
Toll-Free 1-888-313-2665

Visit us on the Internet at www.arcadiapublishing.com

CONTENTS

ACKNOWLEDGMENTS
Chinatown Museum Foundation

This is the accompanying volume for the exhibition "Paper Sons—Chinese in the Midwest 1870–1945," which opened in May 2005, at the new Chinese-American Museum of Chicago - Raymond B. and Jean T. Lee Center.

The production of the book has benefited tremendously from information and assistance given by Phyllis Cavallone, Fr. Michael Davitti, Scott M. Forsythe, Ruth Kung, Dominic Lai, Lucy Moy Lee, Raymond Lee, Raymond Lum, Len Louie, Jeffrey Moy, Ruth Moy, Susan Lee Moy, Elinor Pearlstein, John Rohsenhow, Jean Vondriska, and Wai-chee Yuen. We thank Mrs. Ruth Moy and Dr. Raymond Lum in particular for their generosity in giving us not only advice but also large numbers of images and objects as well.

The Foundation could not have completed the volume without the hard work of its curatorial team, especially the authors themselves, and the strong interest of its Board of Directors. It owes a particular debt to the enthusiasm and constant support of the exhibition production team led by Gwendolyn Moy, who scanned in many of the images and who took an important part in the development of several key ideas. The preparation of all print-ready images was done by Bennet Bronson. The Foundation thanks him for the many hours he spent converting old snapshots into publishable pictures.

The photographs and data used here were generously provided by many individuals, organizations, archives, and libraries. The following have generously allowed us access to images and artifacts and, where necessary, permission to publish them:

Individuals: Bennet Bronson, LaVerne Chan, Philip Choy, Grace Chun, Philip Fong, Chuimei Ho, Eugene Kung, Margaret Larson, David K. Lee, Raymond Lee, Chuck Lee, Raymond Lum, Billy Moy, Jeffrey Moy, Patricia Moy, Ruth Moy, Soo Lon Moy, and Susan Lee Moy.

Institutions: Beloit College, California State Library, Chicago Historical Society, Chicago Metropolitan Lee Association, Chicago Public Library (Harold Washington and Chinatown Branches), Field Museum Library, Gee Kow Oak Tin Association, Hung Mon (Chinese Freemason) Society, Moy Shee D.K. (Moy's Family) Association, National Archives and Records Administration, St Therese School, and Wong's Family Association.

INTRODUCTION

This book was born out of the exhibition, "Paper Sons—Chinese in the Midwest 1870–1945," the inaugural show of the new Chinese-American Museum of Chicago. Both museum and exhibition opened in May 2005. While the book follows the exhibition in terms of content and overall theme, it has a tighter focus. Its main themes are Chinese immigration and Chinese-American identity in the Midwest.

The subject is vast. The resources are rich. Community members and public agencies have been generous with information. Our research team has assembled a mass of archival and oral data plus more than 1000 photographs and 150 objects, and more are coming in every week. Thus, we have had to make many hard choices. This volume only has room for a selection of the photographs. In the end, we had to choose on the basis of who will be most interested in the book: Chinese-Americans, members of other ethnic groups with similar immigrant experiences, and those interested in Midwestern history.

Thanks to the efforts of previous historians, the outlines of the subject are familiar. One learns from these writers that immigrants from South China first came to the Midwest in the 1870s, that they suffered severely from racial prejudice, that due to the Exclusion Act of 1882 the Chinese community had very few women in it, that anti-Chinese laws and feelings began to break down during World War II, that the Exclusion Act was repealed in 1943, and that in recent decades Chinese-Americans have overcome many of the obstacles of the past.

While the present authors know that this outline is accurate, we feel that it warrants a closer look. Interviews with Chinese-Americans of the generation that remembers the Exclusion Act period showed that they had complex feelings about the past. They were proud of the achievements of their families and other Chinese immigrants, but mainly when those achievements were outside Chinatown. We felt that they seemed uneasy about several aspects of the Chinatown past—about the false family names of so-called "paper sons," who entered the country with other people's identity papers; about the ghetto-like reputation of their neighborhood; and—significantly—about being the children of restaurant workers and laundrymen. Some are not just uneasy about this background. They may even be ashamed of it. But we do not fully understand why. Should Chinese-Americans be embarrassed about having

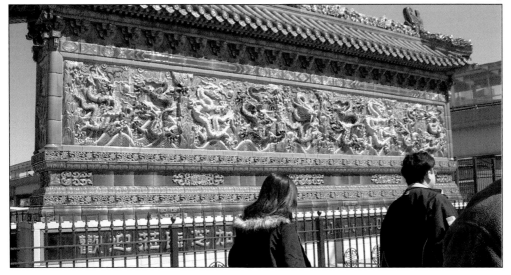

worked in laundries? Irish-Americans and German-Americans, who ran as many laundries as the Chinese, show no signs of shame about it. And washing clothes was certainly less disgusting and better paid than working in slaughterhouses, the economic mainstay of many white Chicago families. In fact, laundrymen made more money than Chinese teachers, as the case of Charles K.S. Lee testifies (see pages 21, 35). Laundry jobs allowed extended vacations, needed few language skills, and required only a six-day week. George Ade, a well-known Chicago writer of the 1890s, observed that on Sundays Chinese laundry workers dressed well and enjoyed life in middle-class style (see page 37). So where did the shame come from?

Paul Siu, a sociologist of the 1930s in Chicago, noted that life for Chinese laundrymen was made harder by the fact that they had left their wives and children back in southern China. He coined the term "sojourners" for such men, who would go abroad to work for most of their lives, returning to their home villages every few years to visit their families. Some writers claim that this sojourner pattern was a response to unjust exclusion laws in America. However, it was much older than that. Sojourners from Guangdong (Canton) and Fujian (Fukien) provinces had already been working in Southeast Asia for several centuries, also without Chinese wives or children, before the first Cantonese left to try his luck in the California goldfields in 1849.

For America, as elsewhere, certain villages and towns in South China specialized in providing sojourners. Many of those communities were quite prosperous due to the money remitted by husbands, fathers, and sons in other countries. Young men went abroad not because of extreme poverty but to seek well-paid jobs. They often played important economic and sometimes political roles in their host countries. When they returned to China, they were respected as successful men. True, before retirement they had to cope with racial prejudice, sometimes extreme, and to face other threats that required courage and ingenuity to survive. But to be able to overcome such hardships abroad was a source of pride, not shame.

Anti-Chinese laws instigated by European-American racists did create a problem that was unique for sojourners in the U.S. Due to those laws, many Chinese immigrants of the working class had to behave illegally in order to enter and stay in the country. An especially common ploy was to buy other peoples' identity papers showing that one was U.S.-born or the son of a citizen, and that as such, one was entitled to enter as a citizen oneself. Such immigrants were known as "paper sons" and had to use their false identities for the whole time they stayed in America.

Is bearing someone else's family name the primary source of shame or guilt, as Confucian tradition seems to suggest? The paper sons (and daughters) we have so far interviewed indeed had a strong urge to talk about it but seldom showed signs of shame or guilt. We further consulted a psychologist who pointed out that being resourceful and successful helps. Apparently many had accepted their false identities. Some just shrugged. "Everybody was a paper son in those days." Perhaps being in the majority also makes it easy to accept.

Yet another possibility is that feelings of shame have been imposed by outsiders. In the past, other Americans often denigrated the Chinese in laundries and restaurants, calling them dirty and secretive, as well as coolies, opium addicts, and rat eaters who spoke a comical form of English. Even the Chinese themselves have sometimes shown negative feelings. Early Chinese at universities and seminaries in Chicago often held themselves aloof from the urban Chinese community of shopkeepers, laundrymen, and restaurant owners. The successful professionals who moved out of Chinatown often felt that they had moved one rung up the social ladder.

Is it possible that this educated, professional group has internalized the stereotypes projected by American racism, and that these in turn have been accepted by the descendents of early Chinese immigrants? If this is true, we think it is too bad. All Chinese-Americans, suburban or urban, intellectuals or business people, should join in celebrating the achievements of the first generations of immigrants.

There is no doubt that the early residents of Chicago's Chinatowns had to make a lot of adjustments and that they suffered in many ways. Yet we have found them to be admirable people—adventurous, resilient, talented, and entrepreneurial. We hope this volume will help readers to see them in the same light.

One

SEEKING A NEW WORLD

CHUIMEI HO

Here rice and grain are easy to get. Friends are easy to have. Housing is easy to set up. Utensils and other material needs are easy to acquire. Business is easy to do.

These are the reasons that a 13th-century sojourning Chinese merchant in Cambodia gave when asked by a visitor why he had left China. Today, immigrants to the U.S., Chinese and non-Chinese alike, still leave their ancestral homes for similar reasons. The Chinese diaspora reached the Americas in the mid-19th century. This volume focuses on their lifestyles in Chicago between 1870 and 1945.

Today there are about 30 to 40 million Chinese in 136 countries outside China. More than half of them live in Southeast Asia, but the United States has the largest Chinese population outside Asia, over 1.6 million.

No Chinese are known to have been in Chicago until the first trans-continental railway was completed in 1869. By 1874 there were already 18 laundries and one tea shop in the central part of the city, all managed by Chinese. They came from the Pacific coast for a more tolerant society after anti-Chinese violence broke out in San Francisco, Los Angeles, and elsewhere in the western part of the country. In the words of Mr. Dong Chow Moy (see page 61) who landed in Chicago shortly after 1876, "The Chicagoans found us a peculiar people to be sure. But they liked to mix with us."

Unfortunately, this ethnic hostility found its way to policy. In 1882 Congress passed the Chinese Exclusion Act, which not only restricted the number of Chinese workers coming to America, but also limited freedom of travel for those who already resided in the States. Hence many Chicago laundrymen were stranded. The stress was intense, but as usual the resourceful immigrants found ways of working around the law in order to stay in this land of promise. The Chinese population in Chicago continued to rise sharply. By 1900 the Census Bureau found 1,462, and there must have been others who avoided government notice. Not everyone came legally. The Chinese Inspector of the Department of Labor in Chicago deported the caught ones.

The 1906 earthquake in San Francisco turned out to be a hidden blessing for Chinese immigrants. Sbsequent fires burned down the buildings where birth certificates were kept. Taking advantage of the absence of proof, many Chinese managed to become citizens, claiming to have been native born or children of native born persons.

Even observers with no knowledge of overseas Chinese are likely to notice three obvious architectural features that assert Chinese cultural identity: religious structures, cemeteries, and Chinatowns. In America Chinese religious structures are not limited to Buddhist or Daoist temples; many Chinese came to the West because they had become Protestants and Catholics. The more traditional Chinese deities were often enshrined in community organizations. The Mount Auburn Cemetery in Stickney has been a resting place for many Chinese-Americans since the 1940s.

Like other immigrants who lack local languages and knowledge, the Chinese have felt the need to stay together. They themselves call their enclaves "Tang people street" [tangren jie], in honor of the early Tang dynasty. They run restaurants, groceries, and souvenir shops in

those enclaves, which westerners call "Chinatowns." The enclaves are often portrayed as seedy and riddled with gangsters and exotic crimes, but also as exciting and romantic. Chicago's Chinatown has its share of fame and blame.

The early Chinese immigrants started as sojourners. They traveled back and forth to be in touch with their roots. By their sojourning, they created the first bridges that have brought Asia to Chicago. Over time, some decided to sink their roots here. The path of assimilation could sometimes be painful, but successful immigrants had to be resilient. After all, it takes new attitudes to live in a New World.

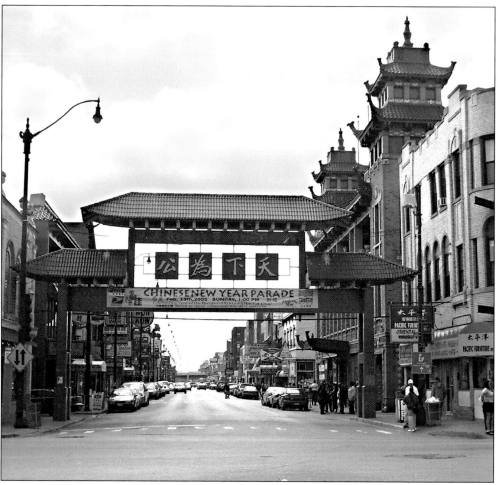

CHICAGO'S CHINATOWN ON CERMAK, 2005. The busy Wentworth and Cermak corner, highlighted by the gateway, is one of the few Chinatowns in America that is still thriving. Over the past 20 years Chicago's Chinatown has considerably expanded its business and residential areas.

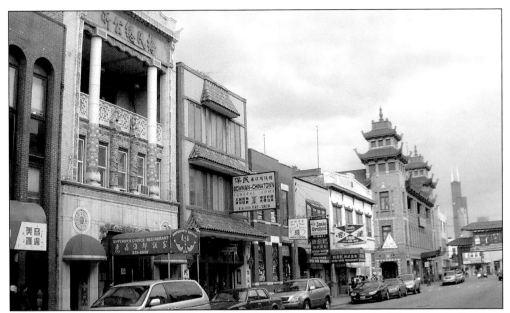

WENTWORTH AVENUE, CHICAGO, 2005. Wentworth Avenue, or the "Ever Lasting" as it is known among Chicago's Chinese, is the major north-south axis of Chinatown and retains today many original buildings. The large twin-tower building, built in 1928, was formerly the headquarters of the On Leong Merchants' Association (see pages 58–60). The Moy Shee D.K. (Moy's Family) Association building on the left was built a few years later (see page 68).

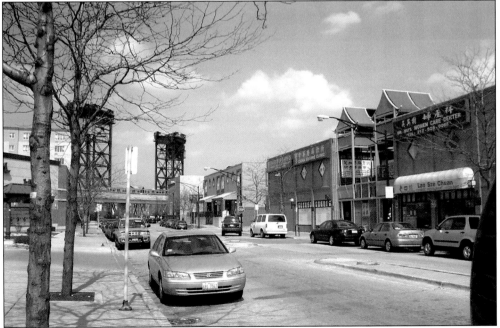

CHINATOWN SQUARE—AN EXTENSION ALONG CHICAGO RIVER, 2005. Built on reclaimed land from the former Santa Fe Railway Depot a block north of the Cermak/Wentworth junction, the growth of Chinatown Square moves in pace with recent immigration of the last 20 years.

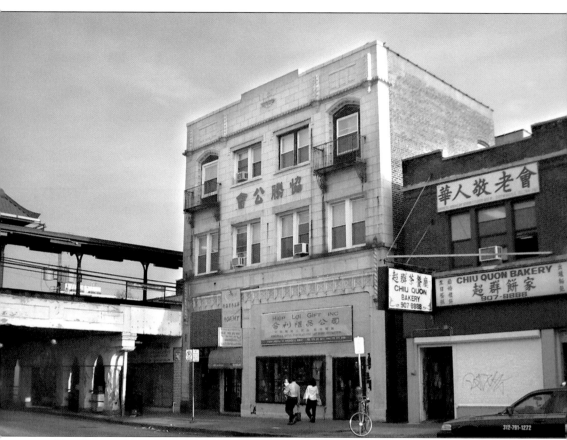

THE NORTH CHINATOWN—OR IS IT VIETNAM TOWN? CHICAGO, 2005. The Argyle/Broadway commercial area displays cultural traits similar to those of the Cermak/Wentworth Chinatown. The difference lies in the people. Developed since the 1970s, the Argyle Chinatown has attracted many Southeast Asian immigrants. The large building adjacent to the CTA railroad is the office of Hip Sing Association.

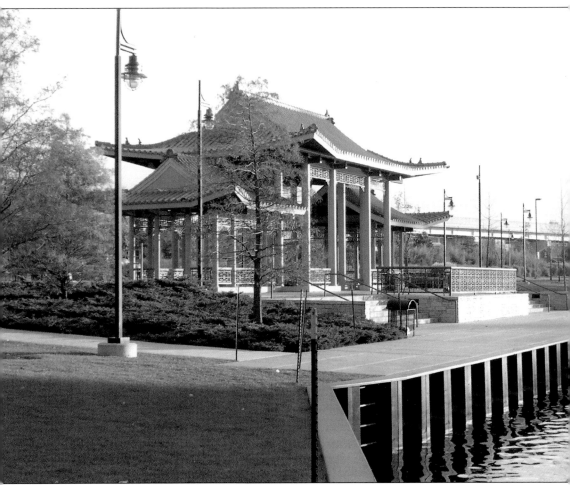

THE PING TOM MEMORIAL PARK, CHICAGO, 2004. Chicago's Chinatown had little recreational space until Ping Tom Memorial Park was open in 2002. Named after a prominent community leader and the son of Tom Chan (see pages 63, 68, 71), the park features traditional Chinese architecture. The community has come a long way in being able to turn a seedy district into a respectable commercial-residential neighborhood.

Chinese Diaspora in 1800-1900

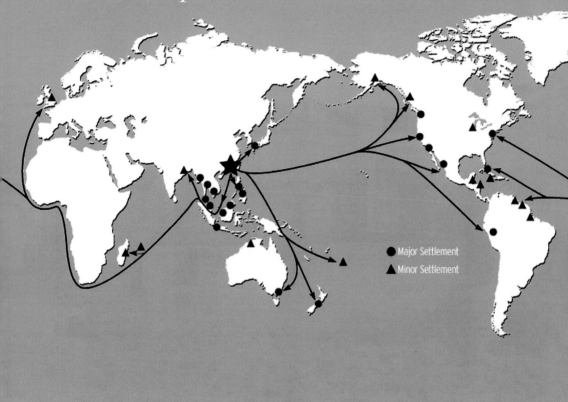

CHINESE DIASPORA. Chinatown might have been seen by many as a small, closed ethnic enclave. Yet for its residents their world was vast and deeply embedded in a global Chinese networking system. They journeyed back to China often, traveled to other cities for business meetings, and visited friends and relatives in other Chinatowns.

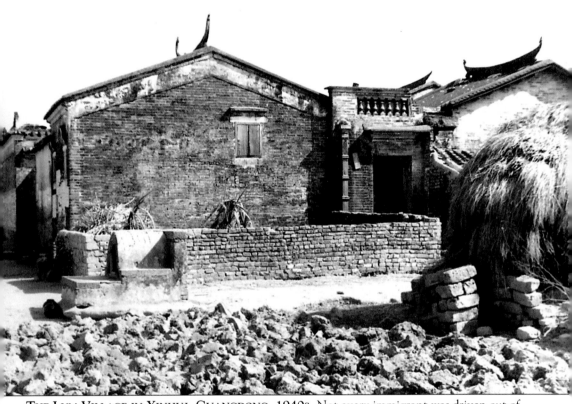

THE LUM VILLAGE IN XINHUI, GUANGDONG, 1940s. Not every immigrant was driven out of his or her hometown by poverty. In South China, men were expected to go abroad to make a living and a name. Dr. Sun Yat-Sen was an outstanding example. The tradition was so strong that men who stayed behind were frowned upon as lacking ambition.

KITCHEN OF A VILLAGE HOME, TAISHAN (TOISAN), GUANGDONG, 1990. For some, life in the home village might have seemed primitive and backward. But the same home beckoned successfully to many returning overseas sons, even though those sons were already accustomed to the convenience of American gas stoves, electricity, and fast transportation.

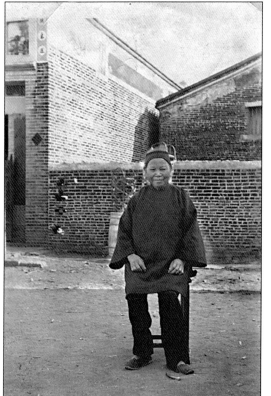

A VILLAGE WOMAN, TAISHAN, GUANGDONG, 1940s. Life in Taishan was no different from life in small towns in other parts of the world, except that Taishan had proportionally more women than men. Tradition claimed that Taishan women were used to having absentee husbands whose occasional visit often brought back a slice of Americanism. Wise parents married their sons off and acquired a grandchild before sending them abroad. Some were willing to take the chance that a grown-up son would return home for an arranged marriage. Mrs. Moy in the picture never saw her son again. She died shortly after her 15-year old son's departure.

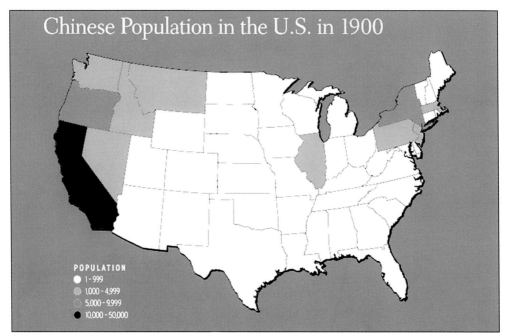

Chinese Population in the U.S. in 1900

POPULATION
- 1-999
- 1,000-4,999
- 5,000-9,999
- 10,000-50,000

CHINESE POPULATION IN THE U.S., 1900. Although the 1900 census showed only 1,462 native Chinese in Illinois, the actual population size must have been larger as Chinese immigrants would not have fully understood the survey procedures involved. Then, as now, San Francisco had the largest Chinese population in the country.

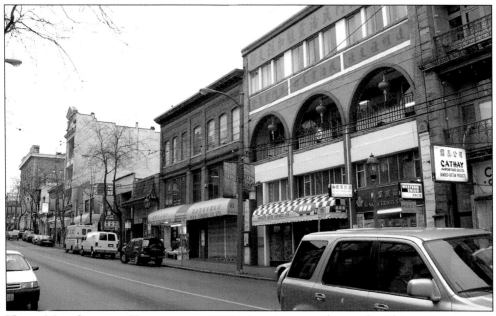

HUNG MON SOCIETY, VANCOUVER, 2004. A major port of entry for Chinese immigrants, Vancouver's Chinatown housed many continent-wide Chinese organizations. The Hung Mon (Chinese Freemason) Society played a major role in helping Dr. Sun Yat-sen to rise to power and to lead the new government in 1911. The Chicago chapter of the society is located on Cermak Road (see pages 65–67).

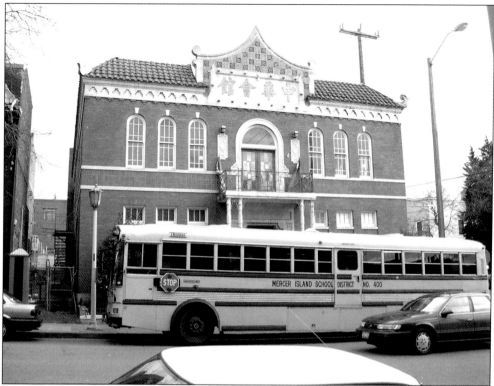

THE CHINESE CONSOLIDATED BENEVOLENT ASSOCIATION, SEATTLE, 2004. As a nation-wide organization that provided social services, business arbitration, and community-building functions to early immigrants, the association, also known as Zhonghua Huiguan, was indispensable in helping new immigrants to settle. The Chicago chapter of the CCBA still leads the community in many activities (see page 61).

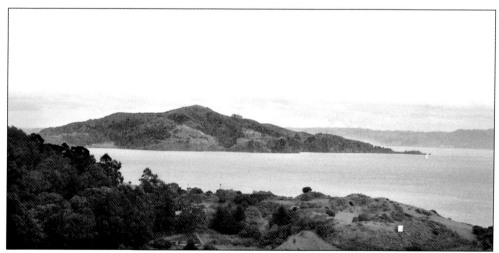

ANGEL ISLAND, SAN FRANCISCO BAY, 2005. Between 1910 and 1940, the island was the point of entry for Chinese immigrants like Ellis Island in New York. The place also kept deportees waiting to return to China. For many, it is a place that evokes bitter memories.

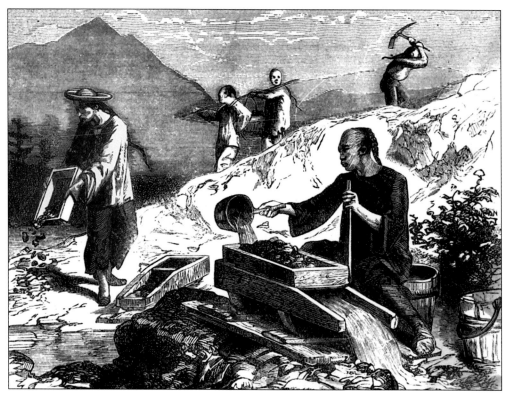

CHINESE GOLD MINING IN CALIFORNIA, 1850S. When Chinese immigrants came to the "Golden Mountain," or America, few had experience in mining, building railroads, owning restaurants, or managing laundries. Yet they learned fast and performed their newly acquired trades well. Their bravery, toughness, and hard work became trademarks for later immigrants.

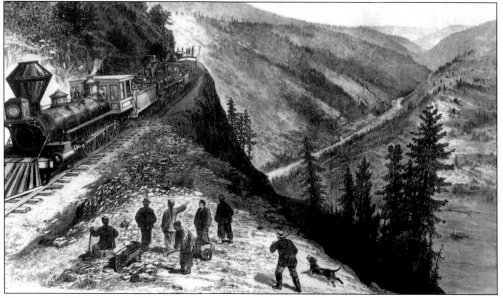

RAILROAD WORKERS IN SIERRA NEVADA, 1860S. The Central Pacific Railway Company hired Chinese immigrants to work on the transcontinental railway.

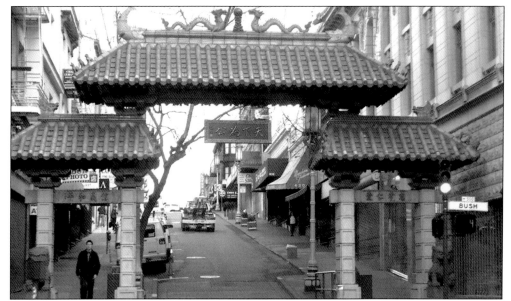

THE GATEWAY TO CHINATOWN, SAN FRANCISCO, 2005. Chinese in Chicago and San Francisco were closely tied by business, marriage, common surnames, and community organizations. Known as the "big port" [da bu] by early Chinese immigrants, San Francisco was without doubt the hub for most North American Chinese.

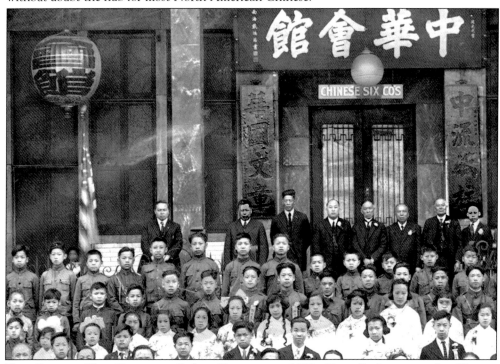

THE CHINESE "SIX COMPANIES," SAN FRANCISCO, 1920. Formally known as the Chinese Consolidated Benevolent Association, or Zhonghua Huiguan, the association became a nation-wide organization that for a long time was spokesman for the community. One of its many programs was to provide Chinese language classes. The photograph shows the seventh class of graduates.

FROM TEACHING TO LAUNDRY MANAGEMENT, CHARLES K.S. LEE, 1918. San Francisco was the gateway for many Chinese immigrants. This gentlemen first came to the United States as a teacher hired by the Chinese Six Companies. Driven by the need to support his family, he moved to Chicago in 1924 to work at a laundry instead.

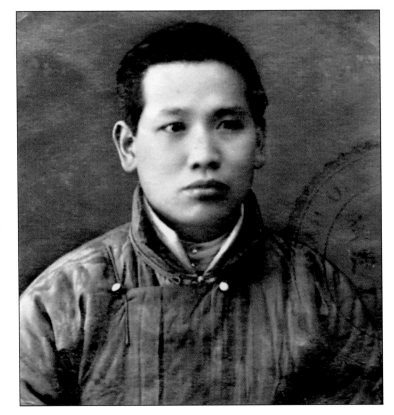

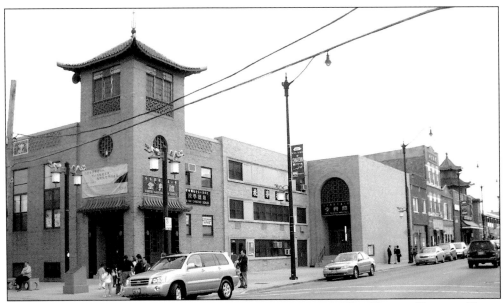

THE CHINESE CHRISTIAN UNION CHURCH, CHICAGO, 2005. The Chinese Christian Union Church on Wentworth Avenue was instrumental in facilitating immigration and helping those newly-arrived to settle in Chicago.

REV. PHILIP LEE OF THE CHINESE CHRISTIAN UNION CHURCH, 1935. Rev. Lee served the church for several decades and was dearly loved by the congregation members. He dedicated this picture of his to Mr. Charles K.S. Lee (see page 21) and his daughter.

CROSS-CULTURAL MARRIAGE OF R. PAUL MONTGOMERY IN CANTON, 1929. Some Chinese immigrants came to the States because they were married to Americans. Yu Hoi Poh practiced medicine in Sanjiang, Guangdong when she met Paul, a missionary from Illinois. In spite of opposition, they wedded in Canton, China. The family eventually came back to the States in the late 1940s.

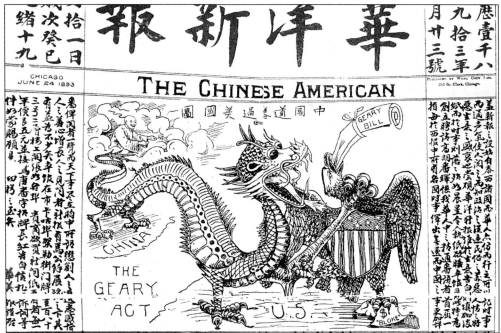

THE CHINESE AMERICAN, THE FIRST CHINESE NEWSPAPER IN CHICAGO, 1893. When the World's Columbian Exposition opened in Chicago, the small but eager Chinese community founded its first newspaper. In this inaugural issue, the editor included the image of a dragon, an important symbol of Chinese cultural identity. 'The Geary Act' refers to the Chinese Exclusion Act, 1882. Today Chicago's Chinatown produces no fewer than eight Chinese language newspapers.

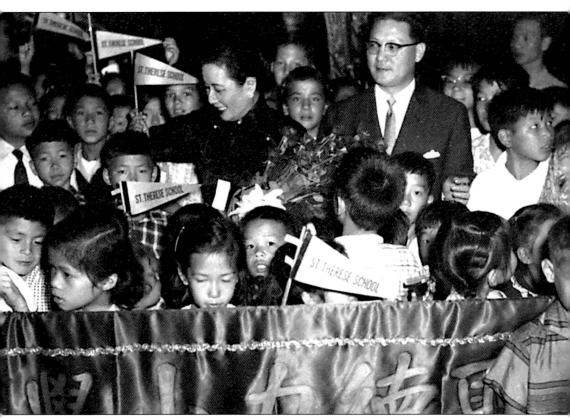

MADAM CHIANG IN CHICAGO, 1942. Sometimes the world came to this small immigrant niche. The First Lady of China was given a huge welcome by the Chicago's Chinese. She visited the St. Therese School, which was then held inside the On Leong Merchants' Association building (see pages 58–60).

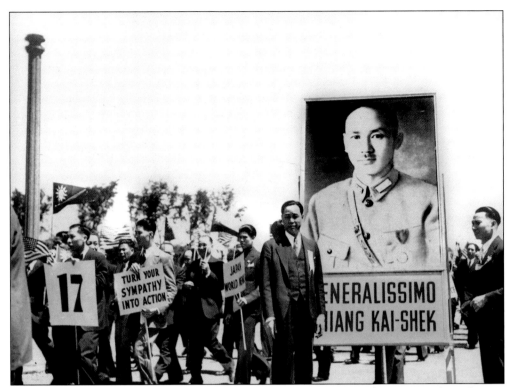

ANTI-JAPANESE CAMPAIGN OF CHINESE IN CHICAGO, 1931. Tragedies were unifying factors. The immigrant community showed solidarity in supporting the campaign. Demonstrations and fund-raising events not only brought the community closer to the mainland, they also helped strengthen the immigrants' identities. American citizens or not, they were part of China.

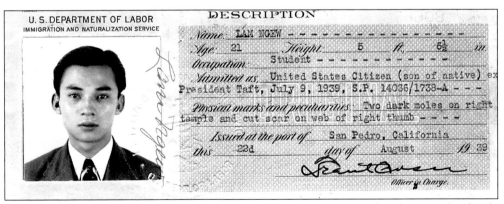

SON OF NATIVE, LAM NGEW, 1939. Many Chinese immigrants lived in a split family pattern, sometimes a hardship driven by circumstances, and sometimes a subtle mechanism of reinforcing Confucian family obligation. Parents of immigrants raised grandchildren who would be reunited with their immigrant parents when grown up. Mr. Lam, who also called himself Joe Lum, was born in China. He came to Illinois and joined his father and uncles, all were born in Honolulu, in the restaurant business.

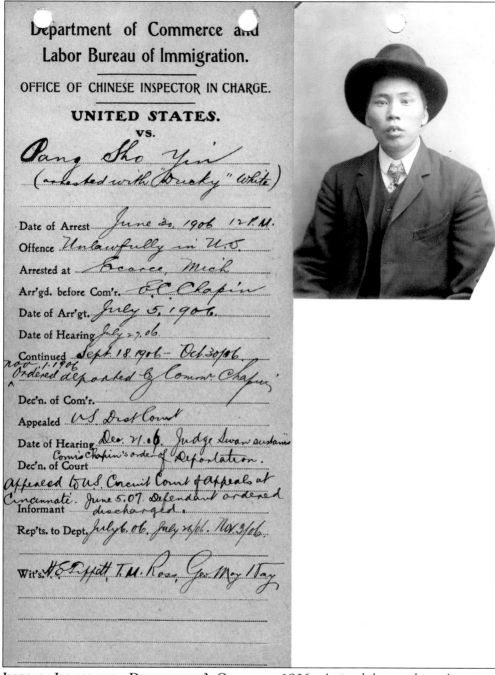

Department of Commerce and Labor Bureau of Immigration.

OFFICE OF CHINESE INSPECTOR IN CHARGE.

UNITED STATES.

VS.

Pang Sho Yin

(arrested with "Ducky" White)

Date of Arrest _June 30, 1906 12 P.M._

Offence _Unlawfully in US_

Arrested at _Ecorse, Mich_

Arr'gd. before Com'r. _E.C. Chapin_

Date of Arr'gt. _July 5, 1906._

Date of Hearing _July 27. 06._

Continued _Sept 18. 1906 – Oct 30/06._
Nov. 1. 1906
Ordered deported by Comr Chapin.

Dec'n. of Com'r. _____

Appealed _US Dist Court_

Date of Hearing _Dec 21. 06. Judge Swan sustains_
Comr Chapin's order of Deportation.
Dec'n. of Court

Appealed to US Circuit Court of Appeals at
Cincinnati. June 5. 07. Defendant ordered
Informant _discharged._

Rep'ts. to Dept. _July 6. 06. July 26/06. Nov. 3/06._

Wit's. _H.E. Tippett, T.M. Ross, Geo May, W Tay_

ILLEGAL IMMIGRANT, DEPORTATION? CHICAGO, 1906. Assisted by a white American called Ducky, Pang Shoyin was caught illegally entering the country in Michigan at the Canadian border. Claiming himself to be a native-born citizen but without any supporting documentation, he was fortunately released one year later as the Bureau of Immigration failed to prove him guilty of false citizenship. It was estimated that about 25 percent of such arrests led to deportation.

No. 20/80.

Office of **Inspector in Charge,**
Port of **Chicago, Illinois.**

September 18, 19**11.**

To **P. L. Prentis,**
Chinese and Immigrant Inspector,

Chicago, Illinois.

SIR: It being my intention to leave the United States on a temporary visit abroad, departing and returning through the Chinese port of entry of **Seattle, Washington**, I hereby apply, under the provisions of Rule 39 of the Chinese Regulations (Bureau Circular No. 25), for preinvestigation of my claimed status as an American citizen by birth, submitting herewith such documentary proofs (if any) as I possess, and agreeing to appear in your office personally, and to produce therein witnesses, for oral examination regarding the claim made by me.

This application is submitted in triplicate with my photograph attached to each copy, as required by said rule.

Respectfully,

Signature in Chinese

Signature in English *Yee Mou Nou*

Address *1051 Milwaukee ave*

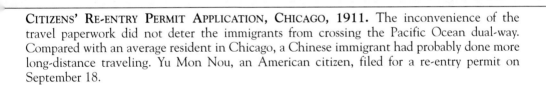

CITIZENS' RE-ENTRY PERMIT APPLICATION, CHICAGO, 1911. The inconvenience of the travel paperwork did not deter the immigrants from crossing the Pacific Ocean dual-way. Compared with an average resident in Chicago, a Chinese immigrant had probably done more long-distance traveling. Yu Mon Nou, an American citizen, filed for a re-entry permit on September 18.

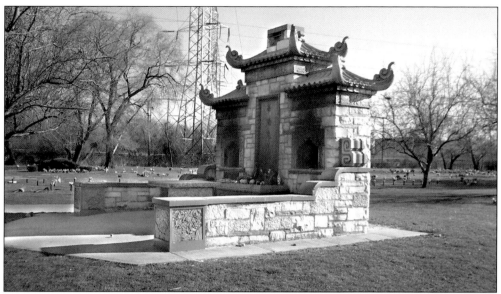

Mount Auburn Cemetery, Chinese Memorial Pavilion, 2005. Not every early immigrant was buried in Chicago because, to many, only the hometown soil could bring eternal peace. But shipping back bodies involved expenses and arrangements, which were not always available, especially for those who were alone here. Fortunately the Chinese Consolidated Benevolent Association bought charitable cemetery plots for those loners. In addition, the continuous warfare in China in the 1930s and 1940s made Chicago's Chinese think more positively about burial in American soil. For some, their roots were not truly sunk here until after they died. The CCBA erected a memorial pavilion in 1948 to commemorate the gone and forgotten.

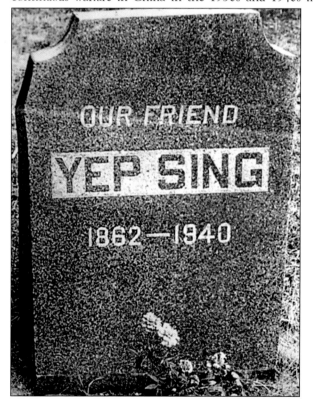

The Tomb of Yep Sing, Wausau, Wisconsin, 1940. A laundryman's life journey could be lonely even after death. Yep Sing operated a small hand laundry alone—no family, no friends. After his death, his neighbors gathered together to bury him and gave him a marker that seems to highlight his solitude.

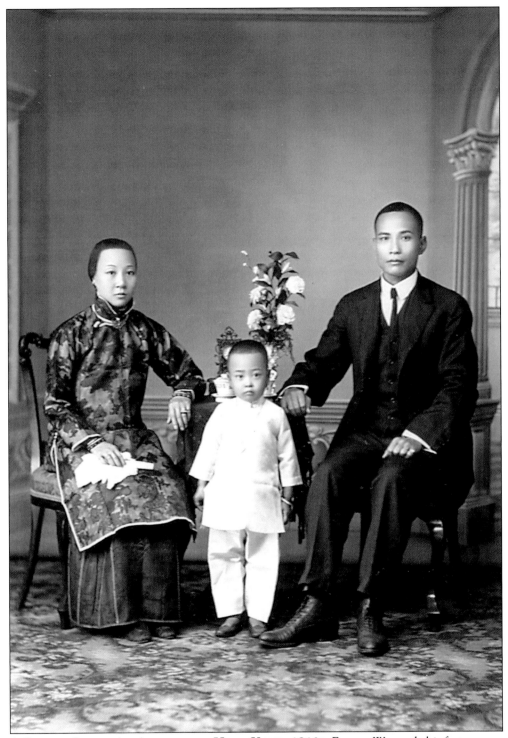

A SUCCESS STORY: AN AMERICAN IN HONG KONG, 1910S. Fenton Wu made his fortune as a realtor and restaurant owner in Chicago. He is shown here in Hong Kong visiting his wife and child. The couple chose to dress in styles that bespeak their cultural traits.

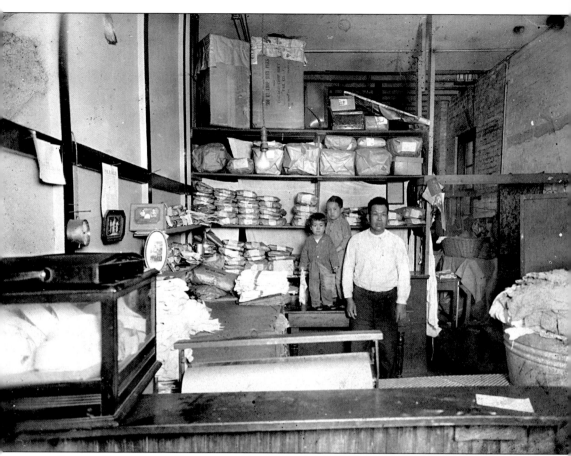

CHINESE IMMIGRANTS FOLLOWING THEIR ARRIVAL. This is a typical Chinese family-managed hand laundry. Clothes to be sorted for washing is in the washtub behind the counter. All the needed equipment and supplies for washing and drying are in the back, invisible to the public. The ironing table with dampened shirts ready to be ironed is to Toy Gow's right. After ironing the clothing is folded and wrapped in the paper taken from the roll immediately behind the counter in the foreground. Behind Toy Gow and two of his sons are packages of clean laundry on shelves ready to be picked up by customers.

Two

FILLING THE RICE BOWL
GRACE HONG CHUN

The Chinese, unlike other immigrants, did not come to the United States to stay. They were sojourners in America to earn enough "gold" or money to support their families and villages in China and to return to their homes in China to retire in comfort.

> *He does not live in America in the sense that his immediate concern is to make money. Soon long working hours and lack of recreation are taken for granted, but his ultimate aim is to make a fortune.*
> –Paul Siu, *The Chinese Laundryman, a Study of Social Isolation*

The Chinese population in the Midwest increased during and after the Columbian Exposition in 1893. Opportunities increased because there was a greater demand for restaurants and laundries. The Chinese found that starting up a laundry was inexpensive and laundry skills were easy to learn. Records show that there were two Chinese laundries in Chicago in 1872 and about 500 laundries by 1926, but business declined in the 1960s due in part to laundromats and the increasing popularity of washing machines in homes. In spite of the hardships involved, laundries offered a relatively good income, but it was a lonely business, as observed by the poet Wen Yiduo while on a visit to Chicago in 1922: "Year comes, year goes, the homesick tear falls . . . Midnight, late night, the laundry lamp glows . . ."

Restaurants were second in number to laundries. Most Chinese immigrants had no experience in cooking but did learn how to please the palates of their customers by developing such American dishes as chop suey. Ornate decoration was expected by the general public to provide an exotic atmosphere. Furniture, art, and carvings were imported from China to furnish and decorate restaurants. Restaurant owners employed family members and other relatives or clansmen in their family business. There were more people working in restaurants than in laundries. According to the 1926 statistics compiled by the Mon Sang Association, there were 910 waiters and cooks out of 1,215 Chinese in Chicago. Unlike laundries, which declined, restaurants increased in number and continue to this day with the introduction of different Chinese regional cuisine.

Chicago's Chinatown was the hub for Chinese who had businesses in Wisconsin, Indiana, and Michigan. They came to Chicago to shop for supplies and visit friends and relatives. Chinatown served as a reminder of the language and food that was missing where immigrant Chinese lived and worked. Farming, although native to most Chinese immigrants, was not a popular practice in the Midwest. The only example cited here was located in Michigan. The farmer sold his produce in Chicago.

There were other sources of livelihood that included grocers, letter writers, and clerks who worked in stores that provided other Chinese merchandise and services to help immigrants feel more at home. Occupations in smaller numbers included carpenters, printers, bookbinders, entertainers, and barbers. On the whole it was not easy for Chinese immigrants to find professional jobs. Educated people often returned to China to further their careers.

First generation immigrants were often engaged in manual labor. The next generation was able to get an American education and branch out into professions their parents and grandparents could only imagine for them.

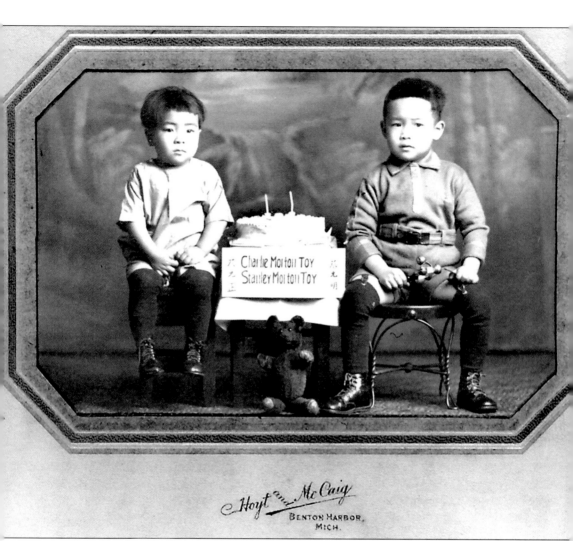

Charlie Morton Toy
Stanley Morton Toy

Hoyt and McCaig
BENTON HARBOR,
MICH.

CHARLIE AND STANLEY TOY, BENTON HARBOR, MICHIGAN. This same portrait is visible on the left side in the laundry seen on page 30. The boys, Charlie and Stanley, born in Michigan, are seen celebrating a birthday. Stanley, the younger brother, died when he was a teenager. During World War II, Charlie was in the Army and served in the European Theater. He was captured by the Germans and listed as a POW. After release, he moved to Chicago and made Chinatown his new home.

FRONT OF LAUNDRY IN BENTON HARBOR, MICHIGAN. Toy Gow is shown pointing out something of interest to his sons, Charlie and Stanley. After the laundry is closed, a door allows customers to drop off their bundles, with names attached. The window signs indicate service provided.

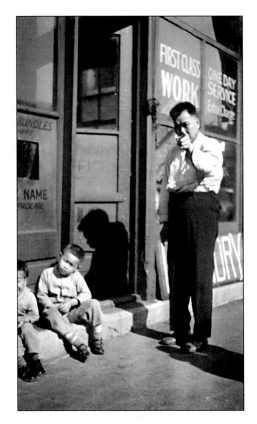

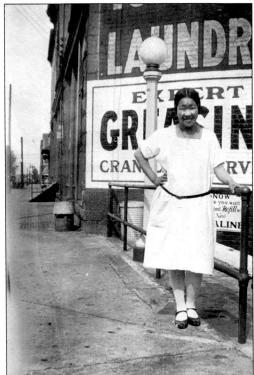

ANOTHER FORM OF ADVERTISING, BENTON HARBOR, MICHIGAN. Ellen, wife of Toy Gow and a native of Walnut Grove, California, poses under a sign painted on the brick wall advertising the family business. There can never be too many signs to let people know a laundry is nearby.

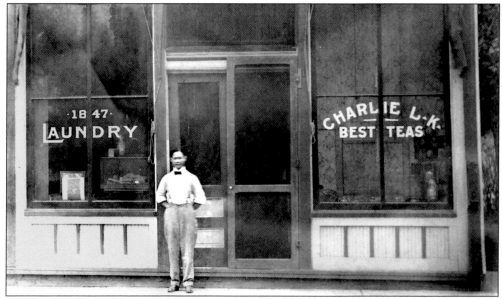

ENTERPRISING LAUNDRYMAN, FORT WAYNE, INDIANA, 1911. An industrious laundryman, Charlie Lum Kiu is shown in front of his establishment. His ambition and hard work is unbounded; he not only managed a laundry but also sold teas to his customers. Note that Lum did not dress like any of the laundrymen depicted in the contemporary cartoons published in non-Chinese media.

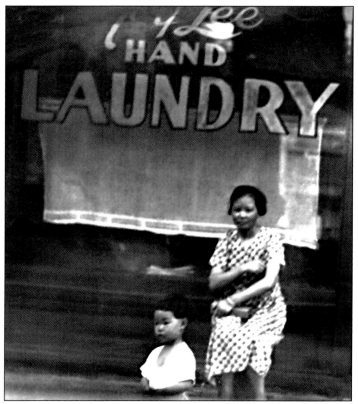

LAUNDRY FAMILY, CHICAGO. Laundry was basically a family business—spouses and children participated. Here a mother and her son enjoy a break from work in front of the Moy Lee Hand Laundry.

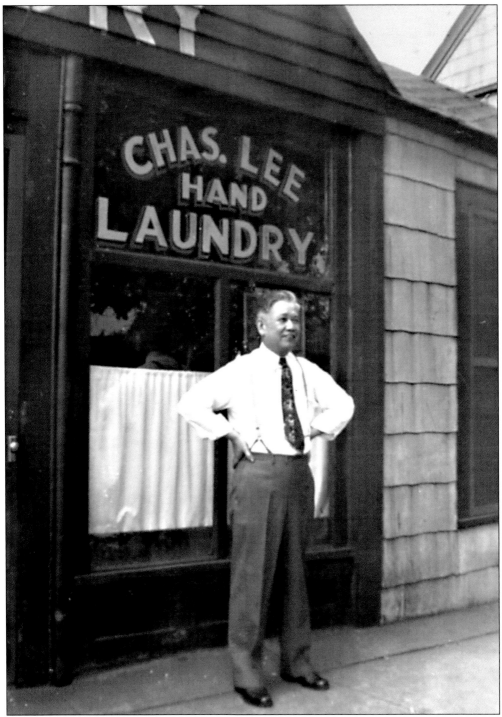

CHARLES LEE HAND LAUNDRY, 90TH STREET, CHICAGO, 1940S. Charles Lee graduated from a teaching school in Guangzhou prior to accepting a teaching position in San Francisco. After teaching for four years for the San Francisco Six Company, he moved to Chicago in 1923 and founded a laundry business. He didn't retire until 1964 (see pages 21, 82).

DOLLAR STEAMSHIP LINE
AMERICAN MAIL LINE
DUPLICATE
CERTIFICATE OF MEDICAL EXAMINATION

(A)

S. S. President McKinley Voy 48

Sailing from HONGKONG

On May 11, 1935 Alien Manifest No.

Ticket No. 1448 Name Moy Shee

Sex F M Age 28 Destination Seattle

(B)

I HEREBY CERTIFY that I have on May 10th 19 35 examined Moy Shee
(Date) (Name)

whose photograph is attached to this certificate and who is an applicant for passage to the Port of Seattle

This examination has been conducted in a reasonable and careful manner to determine applicant's physical fitness to enter the United States under the provisions of the Immigration Act, H. R. 10384, passed by the Sixty-fourth Congress of the United States of America, effective May 1st 1917. AND I FURTHER CERTIFY, that I have found said applicant free from physical defects within the meaning of said act.

In examining for Uncinarisis (Hookworm) I have examined three slide preparations of the applicant's stool and found them to be FREE FROM HOOKWORM AND/OR CLONORCHIASIS OVA.

A Practicing Physician in

Hong Kong
(City or Town)

MEDICAL EXAMINATION REPORT OF A LAUNDRY OWNERS'S WIFE, CHICAGO, 1935. America's many immigration requirements included a medical examination for incoming Chinese. Shown here is the medical report of Mrs. Moy Lee, who came through Seattle to join her husband, Lee My Look in Chicago. The family was about to move to Milwaukee, Wisconsin, to start a laundry.

Day Off in a Laundry, Chicago, 1940s. A father and son are shown behind the counter of their hand laundry, Moy Lee Laundry. They are ready for a well-earned day off. Hanging to the right of the father are customer tickets and bills. In the back there is a mangle used to press flat items such as napkins and handkerchiefs; the water sprayer is suspended above.

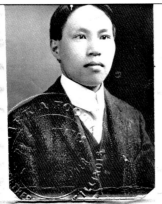
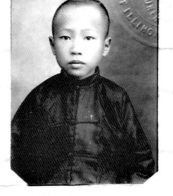
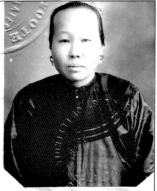

YEE MOY WAY.　　　　　NGUM DOK.　　　　　LEONG BOW JUNG.

In re.
YEE MOY WAY,
Laundryman,
No.2757 West Lake st.,
Chicago,Illinois,
U.S.A.
--
DESCRIPTION
AGE:-Twenty Eight Years.
HEIGHT:-5 Feet, 4-1/4 Inches,
NATIVE OF THE UNITED STATES,ABOUT TO VISIT
CHINA,WITH THE INTENTION OF RETURNING WITH
HIS WIFE AND MINOR SON.

CITIZEN'S RE-ENTRY APPLICATION, CHICAGO, 1911. "During all the time of my residence of Chicago, I have been a laundryman, located, for the six years past last, at No. 2757 West Lake Street," declared Yee Moy Way in his application for a re-entry permit and application to bring his wife and son back with him from China to the United States.

Photograph of Applicant.

Moy Nam, whose photograph is hereto attached, desiring to leave the United States with the intention of returning thereto, and claiming a certificate of his right to return under said Treaty and in conformity therewith, deposits, as a condition of his return, his certificate of registration and his photograph, in duplicate; and a full and true description in writing of himself and of his family, property and debts due him in the United States, as follows, to-wit:

Name; Moy Nam.　　　　　Age; Thirty four years.

Height; Five feet, six and one half inches.

MOY NAM'S RE-ENTRY APPLICATION, CHICAGO, 1910. Laundrymen were sojourners. They visited their hometown in China as often as they could afford. Moy Nam is shown in the photograph on the statement for his application to be readmitted to the United States upon his return from China. The application was made to comply with an agreement between the United States and China in 1894. In order to be considered for re-entry to the United States as a laborer, he was required to declare his assets.

38

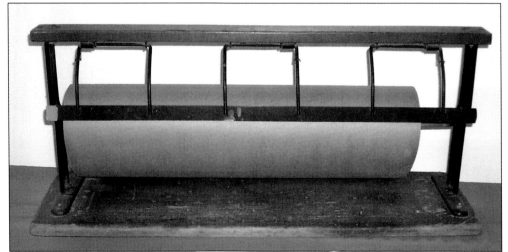

said Office, which is numbered 10447.

That as a means of properly

identifying affiant, Moy Poy, as

entitled to leave the United States

of N.'America on said temporary visit,

to said Empire of China and to return

to said United States from said visit

and be admitted therein upon the ex-

piration of his said visit to China, he

attaches hereto his photographic like-

ness and the testimony of two creditable,

witnesses, not Chinese persons as to the

truth of affiant's statements contained

MOY POY'S RE-ENTRY APPLICATION, INDIANAPOLIS, INDIANA, 1901. As a laundryman at 535 Indiana Avenue in Indianapolis, Moy Poy applied for a re-entry permit before he returned to China for a visit. He provided statements from two non-Chinese guarantors. His assets included a $550 debt owed from Woo Sing. Such funds proven to be due might permit the creditor to be readmitted to the United States from China. As demonstrated by Moy later in life, laundrymen often climbed the social ladder to become a shop or restaurant partner.

BROWN WRAPPING PAPER FROM A LAUNDRY, CHICAGO. All laundries were equipped with rolls of brown wrapping paper on a holder as shown by this roll from the 1960s. The metal slat attached to the wood top was used to tear the paper. The clean laundry was then wrapped in the paper and tied with white string before a ticket was attached for pick-up by a customer. Similar rolls of brown wrapping paper had been used for many years. One such holder can be seen at the front counter of the Toy Gow Hand Laundry (see page 30).

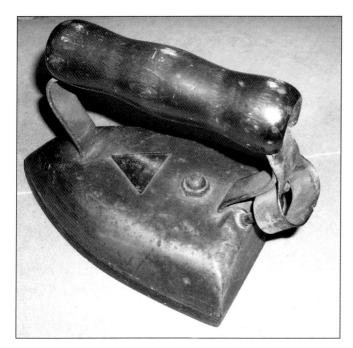

AN ELECTRIC IRON FROM A LAUNDRY, CHICAGO, 1930S. Early Chinese laundries used heavy irons that were heated on a coal-heated potbelly stove. Prior to that the irons were receptacles in which coal was placed for the needed heat source. Preferred for their efficiency, Chinese laundries continued to use especially heavy and hot electric irons even as lighter ones became available for home use.

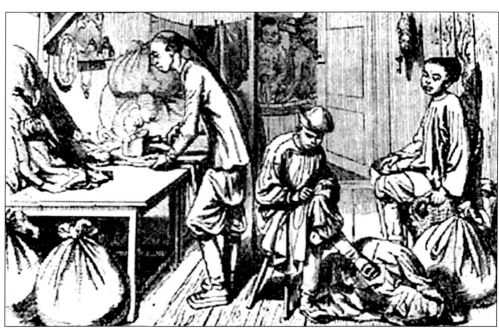

BEGINNINGS: SAN FRANCISCO CHINESE LAUNDRY, 1855. This Chinese washhouse was illustrated in *Wide West* magazine and was drawn by a French artist. Although washing, ironing, and mending required hard work and long hours, such labor was one of the few options open to Chinese immigrants. Washing was generally done in the back or in a yard. Dirty laundry was picked up or brought in by customers and then separated into bags. Mending was done by hand before the advent of the sewing machine. Irons were heated with coal. As shown in this drawing, a family altar was installed along the back wall so as to pay reverence to ancestors and gods.

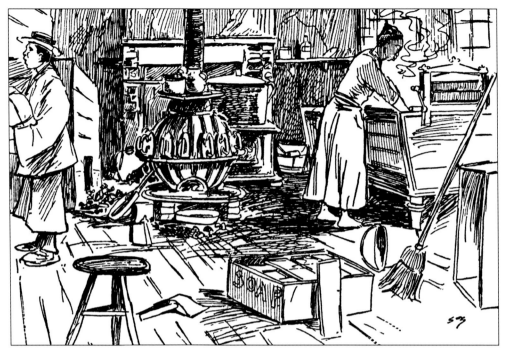

BEHIND THE SCENES: INTERIOR OF A LAUNDRY, CHICAGO, 1890S. Taken from an illustration for columnist George Ade's *Stories of Chicago*, this drawing illustrates the essentials of a laundry at the turn of the 20th century. Laundry is scrubbed in hot water using soap bars from the wooden box on the floor. After washing, the wringer at the end of the wooden tub is used to wring the water out of the laundry that is then hung to dry from the overhead line. Using coal from the box on the left, the coal stove is kept hot enough to heat the irons used to press the garments. As noted by Paul Siu in his 1953 dissertation, *The Chinese Laundryman*, laundry owners sometimes hired African-Americans as day laborers. As seen in this drawing, the woman washing is likely one such laborer.

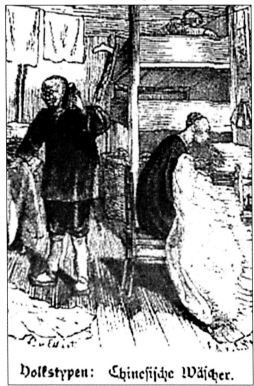

WORKING TOGETHER, 1890S. "The shop of the Chinese laundryman is not merely his place of work, but is also a place for sleeping and cooking." –*The Chinese Laundryman*. Paul Siu and many other researchers observed that the laundryman worked and lived in an isolated and intensive environment. Sometimes the partners—including relatives and cousins—might be at odds with one another. Seen here are some hardworking laundrymen while others rest in the bunk beds.

Volkstypen: Chinesische Wäscher.

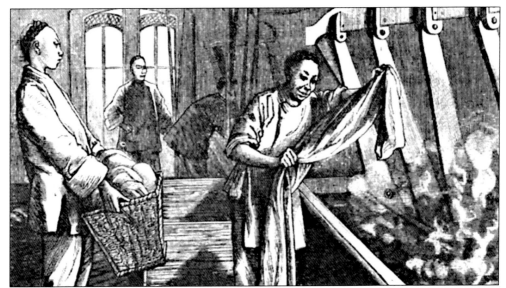

WASHING THE DIRTY LINENS, 1881. From washing over a laundry tub, an enterprising Chinese developed a more efficient model to handle greater amounts of laundry. Using pulleys, hotter water, and other machinery to agitate the dirty laundry, the laundrymen could expand their business.

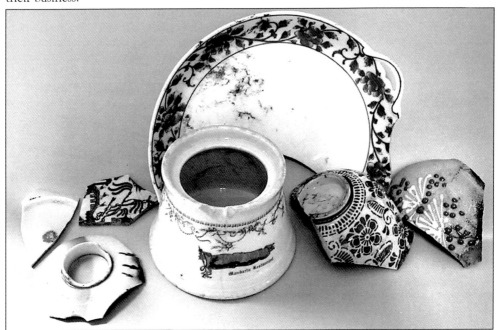

SUGAR BOWL FROM THE KING JOY LO MANDARIN RESTAURANT, CHICAGO, 1910S. Located in the Loop area, King Joy Lo was among the finest Chinese-American restaurants in Chicago. Its features included a live orchestra and a dance floor. Western-style silverware catered to the American customer as well. The menu also advised: "If you experience difficulty in making selections, the floor walker will cheerfully aid you." Shown here are some of the ceramics excavated from the fill near the foundations of the Field Museum, built in 1916–17. The white sugar bowl bears the legend "King Joy Lo" in red and "Mandarin Restaurant" in black.

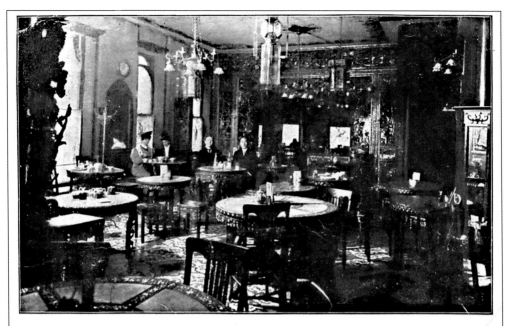

KING YEN LO CO., CHINESE RESTAURANT, COR. CLARK & VAN BUREN STS., CHICAGO

KING YEN LO RESTAURANT, CHICAGO, 1910. This restaurant was located at Clark and Van Buren in what was known as Chicago's original "old" Chinatown. The opulent furniture was made in China. It was fashionable at the turn of the 20th century to use wooden tables inlaid with mother-of-pearl decorations and topped with marble. Restaurants gave up marble-topped tables in the 1960s, as the material was considered unhygienic.

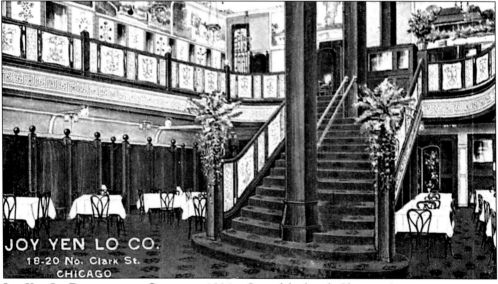

JOY YEN LO RESTAURANT, CHICAGO, 1930s. One of the lavish Chinese-American restaurants in town, Joy Yen Lo Restaurant was located on Clark Street. Columns up the staircase and carved banisters show Chinese workmanship. The walls and the ceiling were decorated with carving and artwork using Chinese themes. Few present-day Chinese restaurants can match the splendid design of Joy Yen Lo.

43

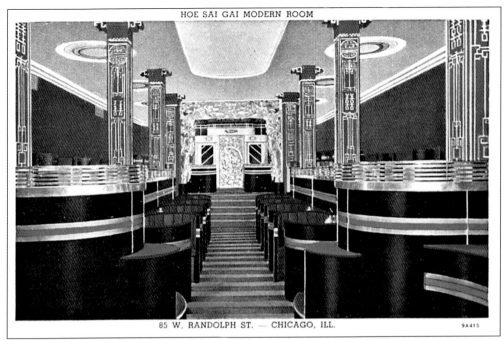

85 W. RANDOLPH ST. — CHICAGO, ILL. 9A415

HOE SAI GAI RESTAURANT, CHICAGO. Located on West Randolph Street in the Loop, Hoe Sai Gai, which means "the Good Old World," was decorated in a fashionable Art Deco style that differed from other Chinese restaurants.

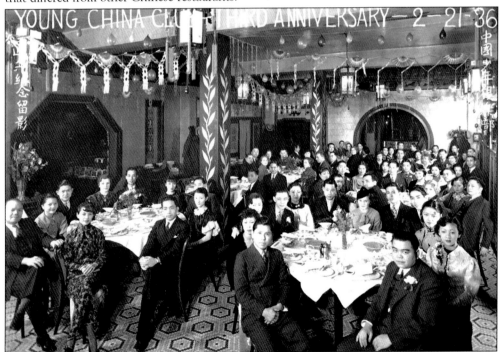

INTERIOR OF PAGODA INN, CHICAGO, 1936. The progressive Young China Club celebrated their third anniversary at the Pagoda Inn Restaurant. The décor of the restaurant was unmistakably Chinese.

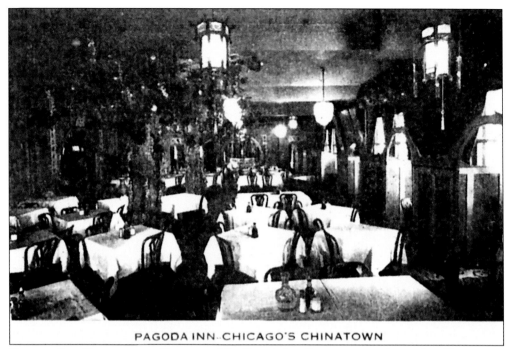

PAGODA INN CHICAGO'S CHINATOWN

PAGODA INN RESTAURANT, CHICAGO. The Pagoda Inn Restaurant was located in Chinatown. Booths with privacy curtains lined the walls of the restaurant. An elaborately decorated shrine was erected at the back of the restaurant, behind the entrance archway. Whether this shrine was functional or merely decorative is not clear.

INVESTING IN CHINESE RESTAURANTS, CHICAGO AND GARY, 1912. This document is an application of a Chinese who desired to travel to China and return to the United States. The applicant, Ing Hong, shows an investment in two Chinese restaurants, one in Chicago and the other one in Gary, Indiana. It is interesting that Ing's correspondence address was Hip Lung & Co. on 315 South Clark Street. The company was owned by the three Moy brothers (see pages 50, 61) who may have allowed their fellow countrymen to use their address, very much like that of a postal box.

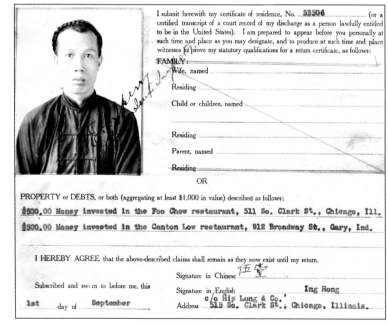

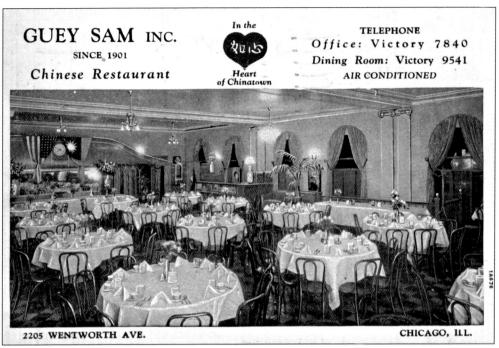

GUEY SAM RESTAURANT, CHICAGO, 1920S. This postcard shows the interior of Guey Sam Restaurant with standardized use of round tables and modernized decor. The restaurant was located on the second floor at the corner of Wentworth Avenue and Cermak Road.

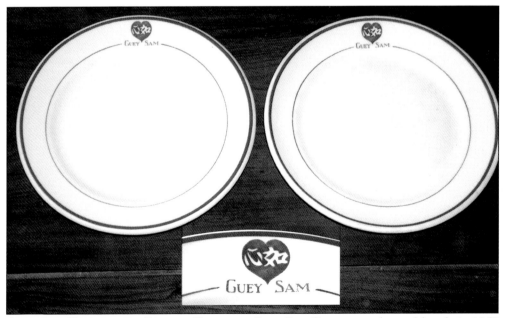

GUEY SAM RESTAURANT PLATES, CHICAGO. Guey Sam Restaurant changed hands in 1950 while maintaining its name. The plates shown here, made by Shenan Company in New Castle, Pennsylvania, were probably used during and after the 1960s.

ORIENTAL CAFÉ, SPRINGFIELD, 1930s. Located on the 400 block of East Monroe Street, this restaurant was popular with local politicians. It was operated by the Honolulu-based Lum family for several decades until 1954. T.Y. Lum, the founder of the café who started a restaurant business in Decatur before reaching Springfield in 1919, emphasized that "[He] like[d] this place and the people."

THE ORIENTAL CAFÉ TEAM, SPRINGFIELD, ILLINOIS, 1930s. Many restaurants outside Chicago maintained strong links with the city. Shown here at the front counter of the Oriental Café in Springfield, Illinois, are the second and third generations of immigrants: Wei Lum, Frank Lum, Jimmy Lum, and Joe Lum. Wei was Frank's uncle. Joe joined the U.S. Air Corps and died in 1949. He was the first Chinese enlisted man at Chanute Field, Rantoul, Illinois. Jimmy was a cousin from San Francisco whose father was a part owner of Quong Hop.

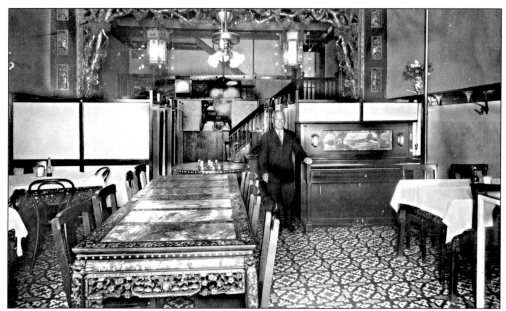

CHINESE RESTAURANT IN MADISON, WISCONSIN, 1930S. Ho Yua Wah sold his restaurant and returned to Taishan for retirement shortly after this picture was taken. Although smaller in scale, the decorative concepts between this and that of Pagoda Inn were similar—they both used Chinese lanterns, marbled-top tables, and lavish wood carvings. The tables were undoubtedly imported from China. A piano was available for the entertainment of customers.

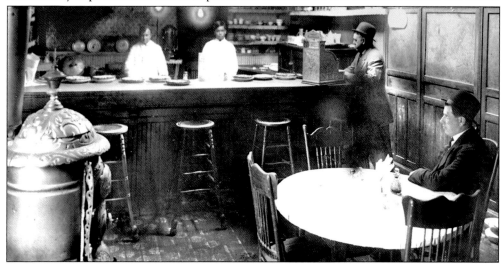

STOP CAFÉ, STEVENS POINT, WISCONSIN, 1940S. Immigrants faced the identity issue with different solutions. Joe Hall, the Chinese bar attendant on the right, changed his name from Ho in order to better assimilate into the local community. Having passed the civil service examination in China just before the founding of the Republic in 1911, Joe came alone to the Midwest seeking a better future. Upon arrival he did not like the few job opportunities he found available to Chinese immigrants. Rather than a Chinese restaurant or laundry he chose to work for an American bar and café. This was not as advantageous financially, but he found the work less strenuous and more to his liking. Sadly, he never again saw China or his family. He died in America without ever returning home.

WING KEE COMPANY, OSHKOSH, WISCONSIN, 1905. Relatives and friends commonly formed business partnerships. The Wing Kee Company, organized in 1892 in Oshkosh, Wisconsin, was owned primarily by Moys, a Ho, a Yep, and a Toy. Charles Toy was the manager at this time, and Moy Wo was probably an investor who did not provide labor to the company. The company shares varied from $1,000 to $2,000.

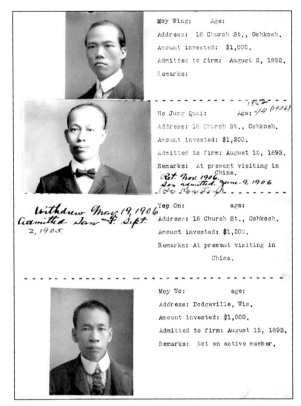

Moy Wing: Age:
Address: 18 Church St., Oshkosh.
Amount invested: $1,000.
Admitted to firm: August 2, 1892.
Remarks:

Ho Jung Quai: Age: *44 (1906)*
Address: 18 Church St., Oshkosh.
Amount invested: $1,200.
Admitted to firm: August 15, 1893.
Remarks: At present visiting in China.
Ret. Nov. 1906
Son admitted June 9, 1906

Withdrew May 19, 1906
Admitted Dan F. Sept. 2, 1905

Yep On: age:
Address: 18 Church St., Oshkosh.
Amount invested: $1,200.
Remarks: At present visiting in China.

Moy Wo: age:
Address: Dodgeville, Wis.
Amount invested: $1,000.
Admitted to firm: August 15, 1893.
Remarks: Not an active member.

YUNG HAI YUEN, CHICAGO, 1911. Sing Moy, a partner at Yung Hai Yuen, applied to the U.S. Department of Immigration to visit China and bring back his wife. Also known as Moy Poy, he landed in San Francisco in 1894, moved to Indianapolis, and then came to Chicago. Moy began as a laundryman, then became a merchant, and finally was a partner of Yung Hai Yuen on 348 South Clark Street. His address was also the Hip Lung store on 325 Clark Street, Chicago (see page 45).

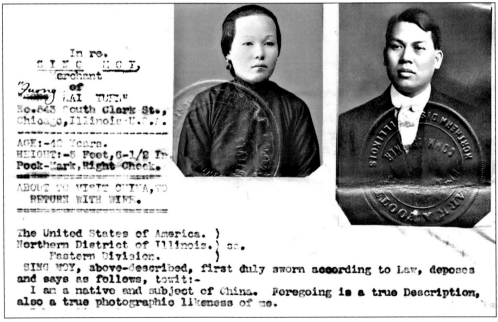

In re,
S I N G M O Y,
Merchant of
"Yung Hai Yuen"
No.348 South Clark St.,
Chicago, Illinois·U.S.A.
AGE:-42 Years.
HEIGHT:-5 Foot, 6-1/2 In.
Pock-Mark, Right Check.
ABOUT TO VISIT CHINA, TO
RETURN WITH WIFE.

The United States of America.)
Northern District of Illinois.) ss.
 Eastern Division.)
 SING MOY, above-described, first duly sworn according to Law, deposes and says as follows, to-wit:-
 I am a native and subject of China. Foregoing is a true Description, also a true photographic likeness of me.

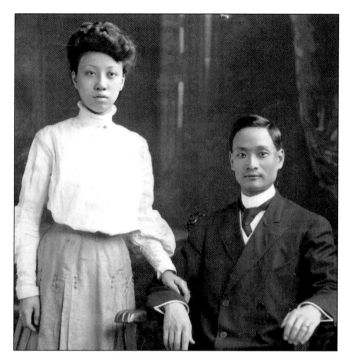

WING CHONG HAI & COMPANY, CHICAGO, 1906. "Chin F. Foin has been a member of the firm of Chinese merchants trading and doing business under the name and style of 'Wing Chong Hai & Co.,' importers and dealers in Teas, Silks, and General Chinese and Japanese Merchandise, at No. 281 Clark Street, in said city of Chicago," so signed Edwin Layman of Illinois Trust & Savings Bank as one of the non-Chinese affidavits for Foin and his wife's application for a re-entry permit. Foin also had some investment in King Yen Lo Restaurant and later owned the Mandarin Inn Restaurant.

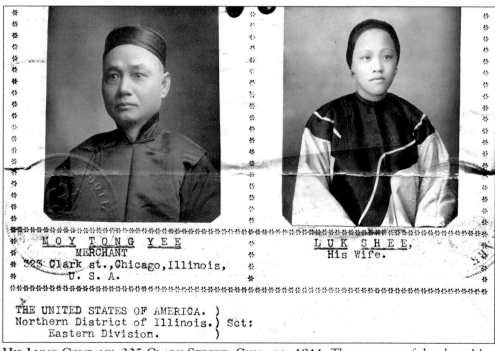

MOY TONG YEE
MERCHANT
323 Clark st.,Chicago,Illinois,
U. S. A.

LUK SHEE,
His Wife.

THE UNITED STATES OF AMERICA.)
Northern District of Illinois.) Sct:
 Eastern Division.)

HIP LUNG COMPANY, 325 CLARK STREET, CHICAGO, 1911. The youngest of the three Moy brothers, Dong Yee is pictured with his new wife, Luk Shee. The three brothers owned the Hip Lung Company. Dong Yee returned to China four times during his 32-year stay in San Francisco and Chicago. During the fourth trip, he married Luk Shee and then applied to bring her back to Chicago.

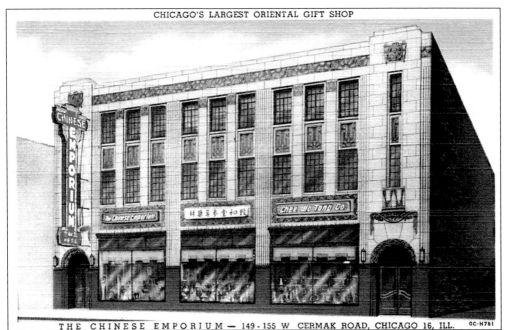

THE CHINESE EMPORIUM — 149-155 W CERMAK ROAD, CHICAGO 16, ILL. OC-H781

CHINESE MERCHANDISE MART, CHICAGO, 1940S. Although this postcard reads "Chicago's largest oriental gift shop," it probably was also the largest in the Midwest. Housed in an exceptionally beautiful Art Deco building, the store carried a wide variety of merchandise and herbal supplies. It remained in business until the 1960s, when the construction of the Stevenson (I-55) highway required demolition of this building.

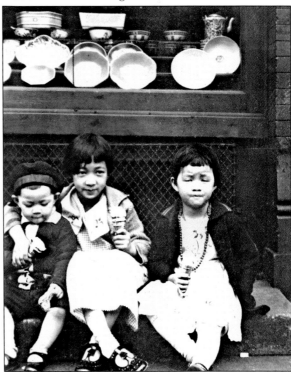

STORE WINDOWS, CHICAGO, 1930S. Merchandise shown in this store window on Wentworth Avenue, Chicago's Chinatown, was representative of the time—ceramic dishes, teapots, and planters. Children of store and laundry owners alike spent a good deal of time at their parents' shops. Here, the three kids enjoy ice cream.

51

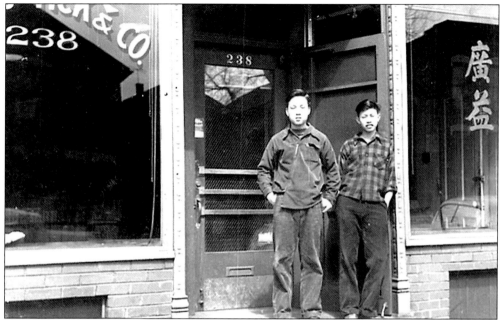

QUONG YICK FOOD IMPORTS, CHICAGO, 1952. Founded by the Lee family in the 1940s, Quong Yick Foods Import was established in this building for more than half a century. Shown here are two young Lees—Raymond and Allen—who worked here for years. As one of the three largest Asian food wholesalers in the Midwest, this company was a purveyor of foodstuff serving

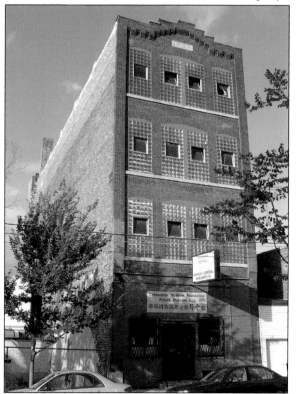

restaurants, grocery stores, and individuals. Tofu was made, and bean sprouts were grown in the basement. The upper floors served as warehouse space and temporary residence. Business was conducted on the ground floor.

QUONG YICK BUILDING, CHICAGO, 2005. Erected in 1896, this building predates Chinatown and was used as a pharmacy before Quong Yick Food Imports moved in. Before the early 20th century, Italian and German immigrants populated this area. Quong Yick Company was closed in 1998 and then sold to Jeffrey Moy, the proprietor of Paragon Book Gallery. In 2004, Raymond Lee, a former Quong Yick employee, donated the purchase sum to Chinatown Museum Foundation to convert the building into a new museum dedicated to Chinese-American history in the Midwest.

POSTCARD OF THE LING LONG MUSEUM, CHICAGO, 1940S. This museum was opened on Wentworth Avenue in 1933 in response to the Century of Progress Exposition. It was closed in the 1970s. The museum featured 24 dioramas of Chinese historical stories and other statues that were designed by Wilson Lim in San Francisco and made in Foshan, Guangdong. It was the first museum in America operated by Chinese immigrants.

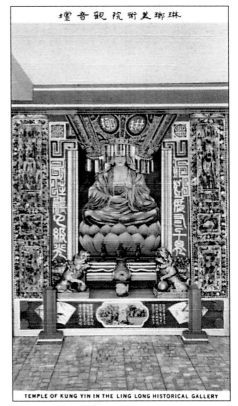

TEMPLE OF KUNG YIN IN THE LING LONG HISTORICAL GALLERY

LINTEL OF THE LING LONG MUSEUM, CENTER PAINTING, CHICAGO, 1933. This papier-mache lintel once crowned the Ling Long Museum's centerpiece, a large painting of the goddess Guanyin. The Chinese characters in the middle read "Ling Long Museum." The Chinese characters on the left read "view what pleases you"; those on the right read "to fathom knowledge." The lintel is now owned by the Chinatown Museum Foundation.

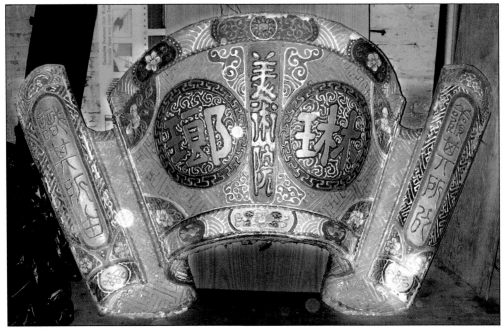

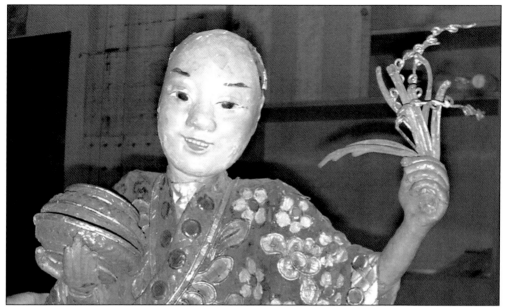

A HARMONY STATUE, LING LONG MUSEUM, CHICAGO, 1933. The two legendary harmony boys always carry a box or two to complement their names in Chinese "he-he." These figures are made out of woven basketry.

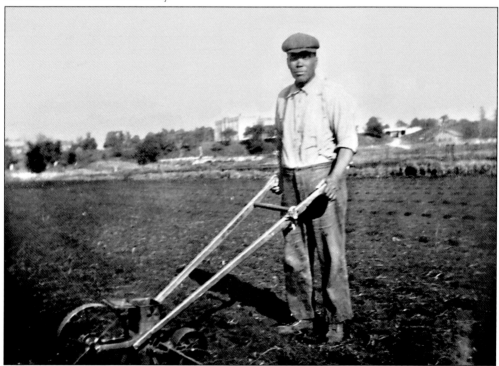

FARM IN BENTON HARBOR, MICHIGAN, 1930s. Few immigrants in Chicago worked on farms. A rare exception, Toy Gow was a laundryman, a farmer, and an antique seller. Here he tills his field on a farm in Benton Harbor, Michigan—his home for many decades. At one time he also owned a restaurant, King Joy Lo, in Benton Harbor. Toy later retired to live in Chicago's Chinatown.

A Farmer-Vendor in Chicago. Toy Gow appears here selling vegetables on a corner in Chinatown in Chicago. As soon as the bok choy or other produce was ready for picking, he brought it from Benton Harbor, Michigan, to sell in Chicago. He also sold vegetables along the road of his farm.

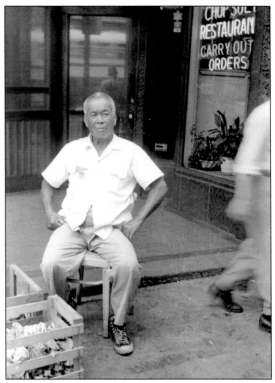

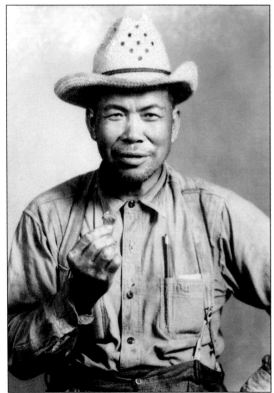

Toy Gow Holding a Lucky Coin, Benton Harbor, Michigan. Toy Gow is shown holding the coin that melted in his pocket during a fiery truck crash in Benton Harbor, Michigan. His small truck crashed into a Holland Furnace Company truck loaded with gasoline drums. His older son, St. Joseph Toy, and the driver were able to extract themselves. Toy Gow was pinned in until passing motorists were able to assist him. Doctors doubted that he would recover. He proved them wrong.

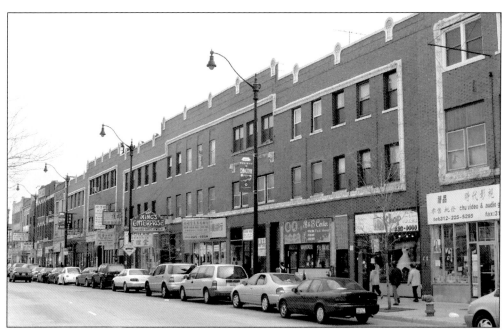

CERMAK ROAD, CHICAGO'S CHINATOWN, 2005. Chinatown today still retains many details of its former appearance. The block west of Wentworth Avenue has changed little since 1911.

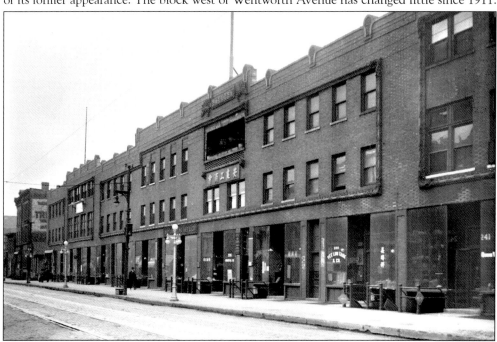

CERMAK ROAD, CHICAGO, 1920S. The same block of Cermak Road must have been seen as exciting, new, and interesting in the eyes of the early residents. Chinese businesses gradually moved from the Loop to this area after 1911, led by the On Leong Merchants' Association. The red-brick buildings, when examined closely, show tiles with dragon designs. The sign of the association was suspended between the two lion-head stuccos. The office occupied a unit on the third floor where the balcony was.

Three

THE RISE OF CHINATOWN
CHUIMEI HO

While restaurants, groceries, and other businesses are the visible, colorful parts of Chicago's Chinatowns, it is easy to notice that these businesses come and go over time. What often lends permanency to Chinese-American communities is the less visible organizations upstairs in the same buildings. Such organizations have been formed for persons with specific interests: merchants, clanship members, religious followers, and those with a political agenda.

In the past these organizations not only played a very important role in binding the community together, but also served as magnets for immigrants and as links to other Chinese communities in the Americas. With few exceptions, they were part of a much larger network that reached Chinatowns all over the Americas and elsewhere in the world. Most importantly, they bridged the psychological gap between Chicago and China, helping to ease the loneliness of sojourners and travelers "to turn this foreign land into our homeland," in the words of the almanac of the Wong's Family Association.

In addition to advancing the interests of its members, each association was also active in providing social and economic services that were traditional Chinese—language classes, immigration services, credit union loans, burial insurance, retirement benefits, arbitration for disputes, festival celebrations, and social clubs.

These organizations along with shops and restaurants stayed close together initially in the Loop along Van Buren and Clark. Beginning in 1911 some business began to move to Cermak Road and Wentworth Avenue, building up the present-day Chinatown. By the 1970s the rest of the Van Buren businesses moved north to Argyle Street, which gradually became a haven for many Southeast Asian immigrants.

The earliest known organizations to be established in Chicago were the Hung Mon (Chinese Freemason) Society and the Moy Shee D.K. Association, both founded shortly before 1900. In the following few decades Chinatown grew rapidly, adding to it chapters of major nation-wide organizations as well as surname or clan associations. For a small community with not more than a few thousand people, those organizations were proportionally quite numerous. It is therefore not surprising to find that the same person had signed up for several organizations, and, interestingly, supported associations with conflicting ideologies or political purposes. Basically, multiple memberships must have served as social insurance that opened doors and opportunities.

Chinese-American organizations also provided much-needed spiritual comfort to their members. Before 1945, formal religious houses for Chinese immigrants were limited to Christianity. The Protestant churches had been very active since the late 19th century, followed by the Catholic Church in the 1940s. Until recently, Daoism, Buddhism, and the ancestor cult did not have separate temples in Chicago. Rather, rites were observed within the organizations where shrines of various kinds were maintained.

In this section we will review the major community organizations of the past, including a few of the older and more influential clan associations.

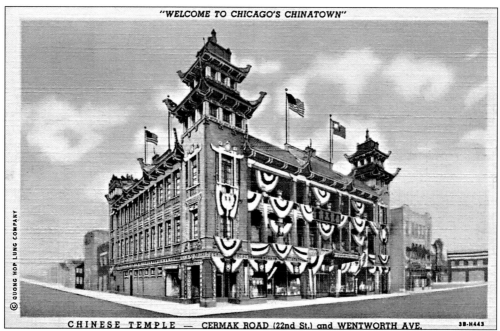

"WELCOME TO CHICAGO'S CHINATOWN"

CHINESE TEMPLE — CERMAK ROAD (22nd St.) and WENTWORTH AVE.

POSTCARD OF THE ON LEONG MERCHANTS' ASSOCIATION, CHICAGO, 1940s. In 1927, Jim Moy, a director of the association, initiated a visionary project to build a landmark in Chinatown. The association hired the architectural firm of Michaelsen and Rognstad to design a new headquarters on Wentworth Avenue. Jim Moy in 1920 had a good experience with the architectural firm when they built Peacock Inn in Uptown for him. Established in 1907 on Clark Street, the association was the Chicago chapter of a nation-wide merchants' association. It also handled many civic functions for members and their families.

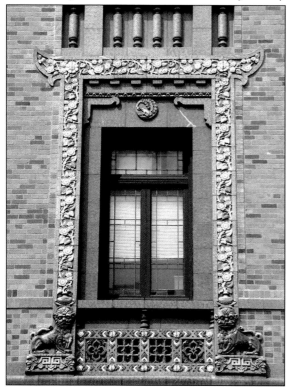

ARCHITECTURAL DETAILS OF THE ON LEONG MERCHANTS' ASSOCIATION BUILDING, CHICAGO, 1928. Most people think these tiles are Chinese. They are not. They were made by Teco, the American Terra Cotta Company in Crystal Lake, Illinois. Now the building houses the Pui Tak Center of the Chinese Christian Union Church.

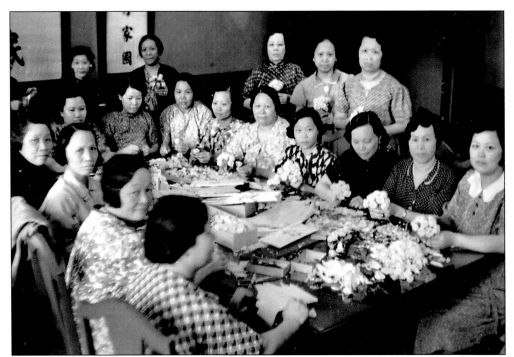

WOMEN IN THE ON LEONG MERCHANTS' ASSOCIATION, C. 1938. On Leong has often been referred to as a fraternal organization, thus creating the impression that no women were involved. While that was true of the business side of the association, it included women in many of its other activities. For example, On Leong provided a meeting place for the Women's Association, which started as a movement against the Japanese occupation of China in the 1930s. This photograph shows a meeting of the Women's Association meeting in one of On Leong's rooms. As shown above, the large glass panel in the background bears the inscription "anwo liangmin" [let our people live in peace]. The name "On Leong" is based on this phrase.

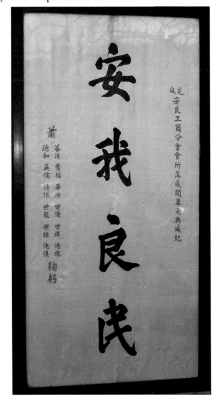

EMBROIDERED PANEL, 1928. The tradition of using calligraphy as decoration ran strong in Chinese communities at home and abroad. In China, beautifully written inscriptions were commonly carved or hand written, while embroidered inscriptions seem to have been popular among temples and Chinese in the U.S. This large panel was once hung inside the On Leong Merchants' Association, as a house-warming gift from a group of Xiu clansmen when the association moved into the new Wentworth building.

Symbols of Civic Pride, 1920s. Chinatown had few architectural wonders. The exceptions were the On Leong Merchants' Association, the Moy Shee D.K. Association, and the Won Kow Restaurant, all built within a few years after 1928. The first, being the largest and most conspicuous of the three, was admired by local residents and tourists alike. It has often served as a backdrop for many photographic opportunities. The association also offered Chinese language classes, as indicated by the sign on the glass door.

A Center for Peace or for Crime? 1928. In 1989, the Federal Government closed the Chicago branch of the On Leong Merchants' Association, claiming that it had been the scene

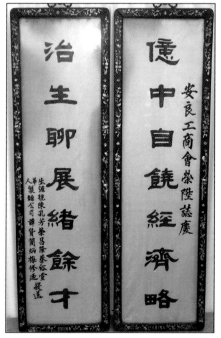

of unlawful tax and gambling activities. The investigation had been initiated by a murder with New York connections. The case revived memories of the so-called "tong wars" of the early 20th century. The federal prosecutors tried hard to prove a case for racketeering, with implications of drug trafficking, immigrant smuggling, prostitution, and other crimes. In the end, however, On Leong was convicted only for not paying taxes. The government seized the association's building and its contents—a great blow to the Chinese community's morale. Association founding members certainly did not think of it as a place for crime. The embroidered couplets in this photograph were gifts from respectable community leaders such as Tom Chan and Chen Kongfang. The couplets read "Among many disciplines business must have priority; [but] those alive must also extend their talents beyond making a living." Encased in nicely inlaid wooden frames, the donors apparently wanted to add a touch of Americanism by putting the English word "China" at the bottom of the frames.

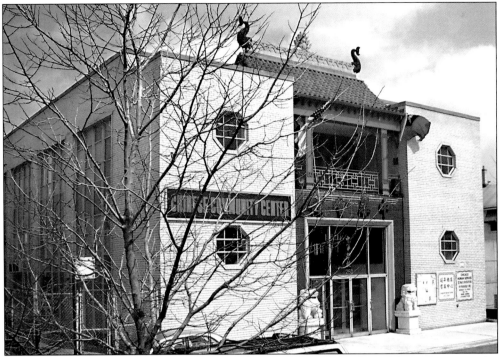

CHINESE CONSOLIDATED BENEVOLENT ASSOCIATION (CCBA), 2005. The association, also known as the Chinese Six Companies or Zhonghua Huiguan, had many functions (see page 20). One was to serve as an arbitration court for Chinese businessmen, thus helping to uphold community harmony. Established in 1906, the CCBA soon passed and enforced regulations that no new restaurants or laundries should be established within 500 feet of existing ones. In 1916, for instance, a laundry was fined $850 by the association for being too close to a rival; the rival got the money as compensation. Community leaders like Moy Dong Chow were called upon as witnesses.

MOY DONG CHOW'S OFFICIAL PHOTOGRAPH, 1900S. Wu Tingfang, the Imperial Chinese Ambassador to the U.S., came to Chicago in 1909 to support the founding of a formal school organized by the CCBA. The Qing Dynasty Overseas Residents' School was opened in March with 29 students. The school made Wu its honorary first principal. The president of the new school, Moy Dong Chow, is shown here in a fourth rank official title, which was awarded by the Qing government probably due partly to his dedicated community service (see pages 65, 66, 85). At the turn of the 20th century, the Manchu government was open to bestowing or even selling official titles to overseas Chinese.

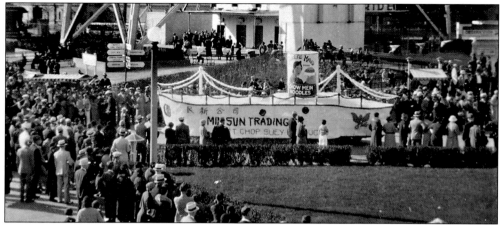

BRINGING THE COMMUNITY TOGETHER: 1933 PARADE. The Century of Progress Exposition came against a backdrop of a disturbed community—the anti-Japanese campaign was well on the way, the Depression was affecting every Chicago citizen, and yet, CCBA was able to pull the efforts together and to organize the first and most spectacular parade for the Chinese community on October 1, 1933. The parade included 13 floats, five bands, a dragon, and lion dances. Shown here in front of Soldier Field is the float sponsored by Minsun Trading Company, an importer of Chinese food products located on the 2000 block of La Salle Street.

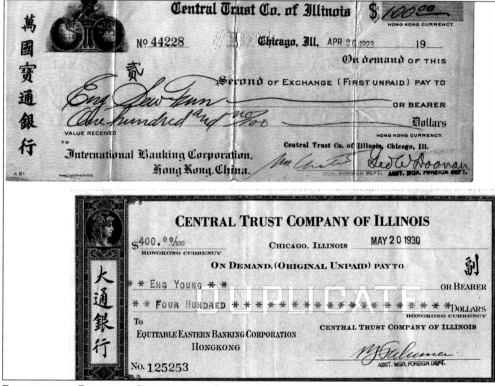

REMITTANCE: BUILDING CONNECTIONS BEYOND CHICAGO, 1920s–1930s A service provided by the On Leong Merchants' Association and the CCBA was to help immigrants transfer money through local banks back to Hong Kong and China. Immigrants who wanted to spare the time and challenge of dealing with English-speaking clerks welcomed such services.

HIP SING ASSOCIATION, ARGYLE STREET, 2005. Established in 1900, the Hip Sing Association, a rival conglomerate merchant guild of the On Leong Merchants' Association, remained on the Old Chinatown on Clark Street until the 1970s when the area was cleared for urban development. It moved to Argyle Street in Uptown.

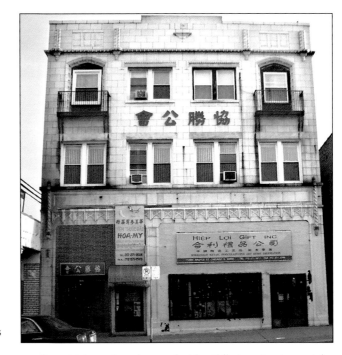

Historically, the two nation-wide merchant organizations had been at odds with each other since the late 19th century. The most spectacular conflicts took place in New York and Boston, while here in Chicago the rivalry was generally non-violent. The New York and Boston outbreaks received much attention from the English-language media, which produced many lurid, wildly imaginative articles about Chinese gangsters and "tong wars." Branches of the two associations in Chicago were made to share the blame and shame.

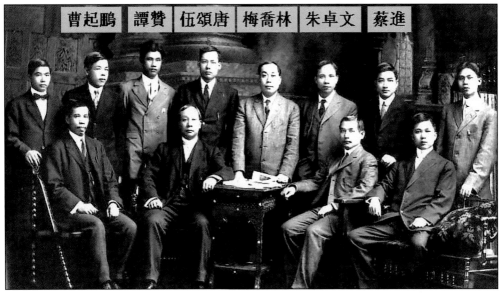

曹起鵬　譚贊　伍頌唐　梅喬林　朱卓文　蔡進

SUN YAT-SEN IN CHICAGO, 1910. What went on in China impacted Chicago's Chinese community. At the dawn of the new Republic of China, competing politicians from the mainland split the community politically. Here the future president of the Republic of China, Sun Yat-sen, sits second from the right in the front row among his hosts in Chicago. Tom Chan, who was to grow into a prominent community leader, was identified as the third from the left in the back. (Another source showed that he was the fourth from the left.)

THE KUOMINTANG BUILDING, WENTWORTH AVENUE, 2005. In 1910, Chicago became the second American community to establish a branch of Sun Yat-sen's political vehicle, Tongming Hui, renamed the Kuomintang in November 1911. The community demonstrated an unusually unified front in supporting the party in leading a new Republic of China. To celebrate the birth of the new regime, at 7:00 p.m. on January 9, 1912, Chinatown set off several hundred thousand rolls of firecrackers donated by individuals and businesses. The On Leong Merchants' Association pledged 200,000 rolls of firecrackers, the King Joy Lo Restaurant 10,000 rolls (see page 42), the King Yen Lo Restaurant 20,000 rolls (see page 43), and Chen Kongfang 10,000 rolls (see page 60). And there were numerous small

donations of 50¢ from the general pubic. The party's office has been located at its present address since 1952. The top floor of the building is now the home of the Sun Yat-sen Memorial Gallery.

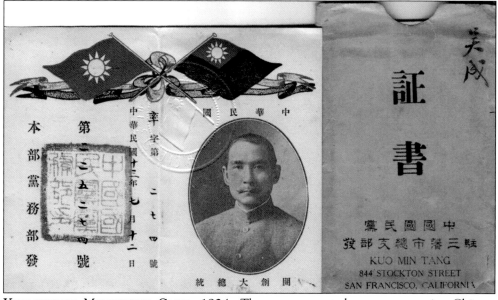

KUOMINTANG MEMBERSHIP CARD, 1924. The party attracted many progressive Chinese Chicagoans. Eng Sing came to Chicago in 1924 and immediately joined the party. Shown here is his membership card, issued by the party's headquarters in San Francisco. Eng paid $6 for annual membership and donated another $3 as a contribution.

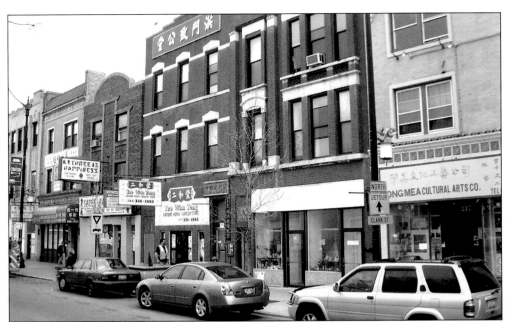

HUNG MON (CHINESE FREEMASON) SOCIETY, CERMAK ROAD, 2005. Another nation-wide organization, the Hung Mon Zhigong Tang Society in Chicago was established well before the end of the 19th century. Formerly a secret society with roots in South China going back to the 1600s, the Hung Mon Society had a strong political agenda and helped to spearhead the 1911 revolution against the Qing Dynasty. Most early Chinese immigrants to the U.S. came from parts of South China where revolutionary feelings were strong, so it was natural for them to join the society. In recent decades, Hung Mon has become affiliated with European-American Masonic organizations. It uses some Masonic symbolism and, with the full approval of Illinois Masonic Lodges, calls itself the Chinese Freemasons Association.

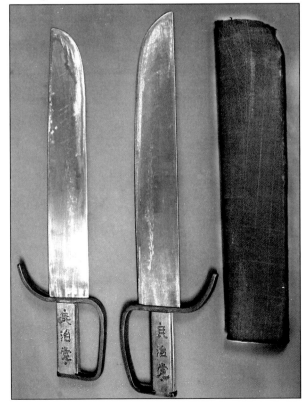

CEREMONIAL UTENSILS OF THE HUNG MON SOCIETY, 1930S. Like American and European Freemasons, the Hung Mon Society in the old days required new members to go through an initiation that involved a series of symbolic rituals. The choppers are among their ritual utensils. The rituals were performed in front of the shrine, sometimes with temporary "gates" that each represented an oath of loyalty and helped to bind members together.

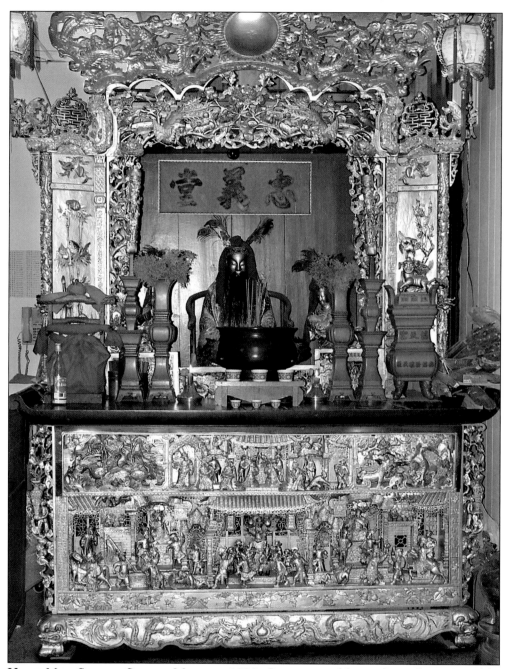

HUNG MON SOCIETY SHRINE, MADE IN 1894. Commissioned by no fewer than 16 wealthy community members, this splendid shrine was made in Hong Kong in 1894, possibly the year that the Chicago chapter was established, thus making it the oldest documented Chinese organization in the city. It is interesting to note that the leaders of Hung Mon, despite the organization's revolutionary history against the Qing government, sometimes chose not to take sides in political issues. Among the donors to the shrine was Dong Chow Moy, who was also elected as president of Qing Dynasty Overseas Residents' School in 1909 (see page 61). At the same time the school's honorary principal was Ambassador Wu Tingfang, a loyal member of the Qing government.

GUANGONG, THE GOD OF WAR, HUNG MON ASSOCIATION. Early Chinese immigrants in Chicago did not build individual temples for their traditional gods. Instead, they worshipped at shrines built by community associations. Guangong, a historical figure of the 3rd century, was the patron saint of businessmen, policemen, firefighters, and close friends. His image was featured in the shrines of the Hung Mon Society and On Leong Merchants' Association.

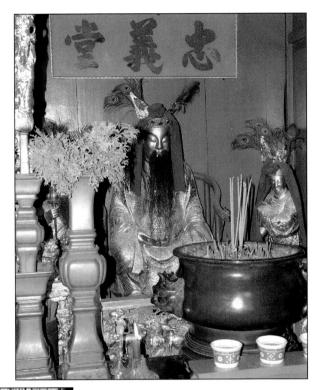

DETAILS OF THE SHRINE. Traditional Chinese architectural and furniture items were often decorated with carvings that depicted well-known drama scenes. In a religious context, such scenes carried an extra layer of meaning to signify a desire to entertain and please the deities. Of course, a well-carved (and expensive) shrine also served to show off an association's wealth, power, and ability.

THE CHINESE AMERICAN CITIZENS' ALLIANCE. Known in Chinese as the Tongyuan Hui [Society for People of the Same Origins], this nation-wide association set its agenda in fighting for civil rights for American-born Chinese and their children, including those born in China (see page 124). The Chicago Lodge of CACA was established in 1916, located on Wentworth Avenue facing 22nd Street. The alliance recognized the importance of building community support and was engaged in many kinds of economic and social activities. It provided loans, social security-type investments, burial insurance, and educational classes for members. Tom Chan the community leader was a member of the alliance, as indicated in the dedicatory text on a mirror he gave the Moy Shee D.K. Association (see page 71). In 1930 Eng Sing paid $5,000 to CACA in order to buy one share of a real estate investment.

THE FRONT OF THE MOY SHEE D.K. ASSOCIATION, WENTWORTH AVENUE, 2005. The family or surname associations have played an important role in Chinese-American communities, initiating newcomers and providing stability for old residents. Membership in such associations is open to people with the same last name but not necessarily related by blood. The two oldest surname organizations in Chicago are those of the Moy and Yuan families; both claim to have been established in the late 1890s, with the former having the largest membership. As part of the larger global network of surname associations, Chicago's Chinatown branches are well-connected with other Chinatowns in Americas and the world. The association's first office was on Clark Street. In 1927, it moved to its current address on Wentworth Avenue (see page 11).

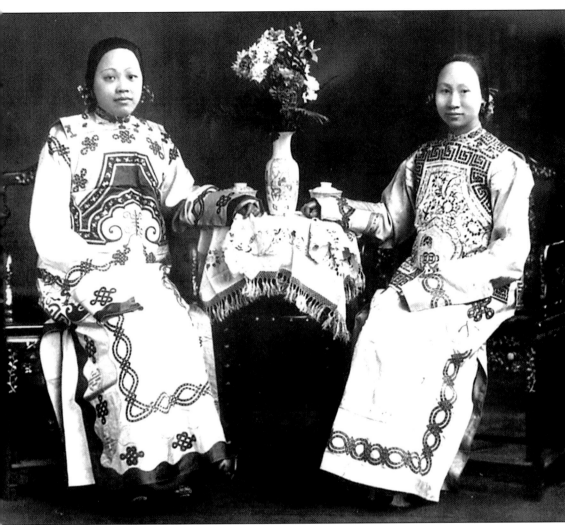

TWO MOY SISTERS-IN-LAW, CHICAGO, 1910S. Membership of the Moy's Family Association included wives and children. The wives of Doug Chow Moy (left) and Doug Yee Moy participated in many formal and informal social meetings there (see pages 50, 84).

THE MOY SHEE D.K. ASSOCIATION SHRINE, 2005. The shrine of a surname organization usually dominates the interior of its main meeting hall. In front is a table that holds the traditional five-piece altar set: a censer, two flower vases, and two candlesticks. A carved gold-lacquered screen and altar appear behind, with a representation of the chief deity or ancestral parents in the center. Rows of tables and chairs are arranged along the central axis and on both sides of the hall.

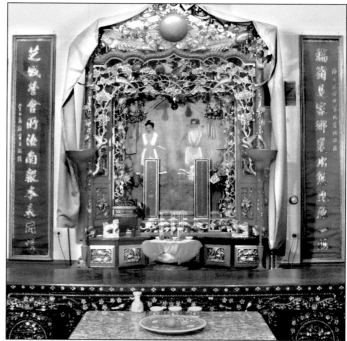

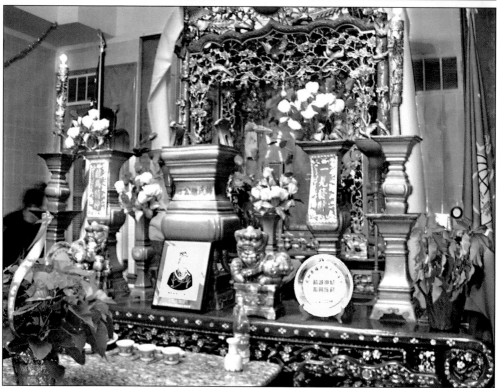

DETAIL OF THE SHRINE AT MOY SHEE D.K. ASSOCIATION, 2005. The Moys' shrine, shown here, honors the first couple who started the line in South China. The offering table, beautifully inlaid with floral patterns, was made in Canton, China.

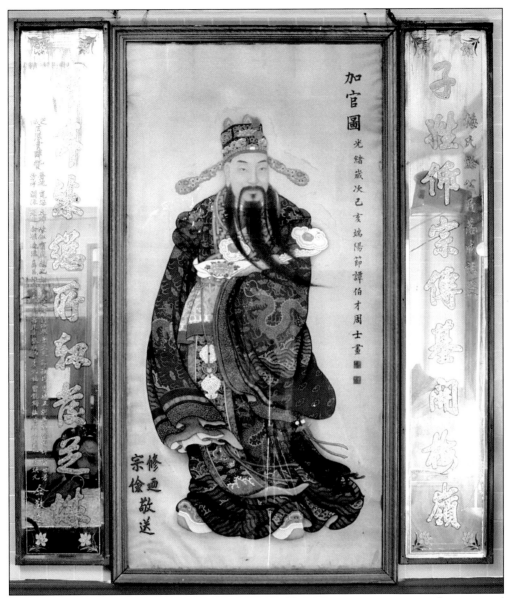

MOY SHEE D.K. ASSOCIATION PAINTING, 1894. Most surname organizations have moved a number of times, so that early records are difficult to find. While one is not sure of the association's exact date of establishment, one can surmise that it was shortly after 1894, based on the date contained in this congratulatory painting, which is spectacular in details and size. The couplets inlaid in glass were gifts from community leader Tom Chan (see page 63). The painting must have been commissioned and brought to Chicago. It was done by a well-known artist, Tan Zhoushi, a native of Kaiping, Guangdong. The theme of the painting, which shows an official, is about promotion.

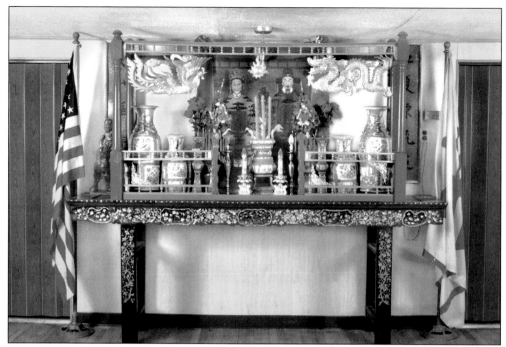

THE WONG'S FAMILY ASSOCIATION SHRINE, 2005. In Tin C. Fan's 1926 dissertation *Chinese Residents in Chicago*, written for the University of Chicago, the association was included under the name "Hwang Kiang Hsia Tong." The association moved to its current Wentworth Avenue building in 1945 and changed its name to its current one later. The Wong's shrine honors its first couple of the lineage with painted images mounted on the shrine screen.

LANTERNS OF THE WONG'S FAMILY ASSOCIATION, 1950S. Chinese tradition requires lanterns in red for happy occasions. Hence most lanterns used in front of the shrines of surname and community organizations (and restaurants as well) are red or brightly colored. White lanterns are reserved for funerals and other sorrowful events and would normally be discarded afterward. This pair of white lanterns on the balcony of the Wong's Family Association would have been considered bad luck back in China. In Chicago, however, white lanterns evidently had no such meaning, perhaps due to the colorful painted decoration.

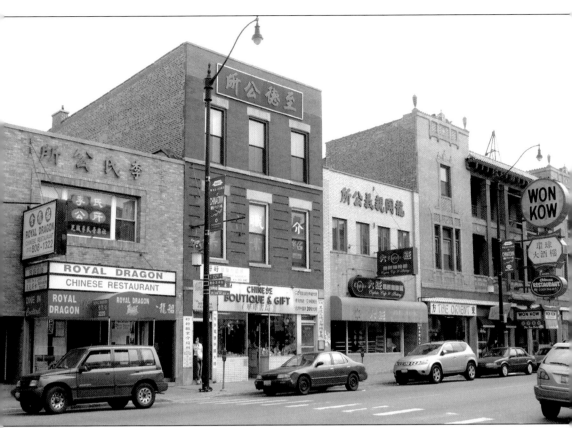

CHICAGO METROPOLITAN LEE ASSOCIATION, WENTWORTH AVENUE, 2005. The Lees were the second largest surname group in early Chicago, after the more numerous Moys. The exact founding date of the Lee Association is not clear, but it was already noted in Tin C. Fan's 1926 dissertation. The association's first office on Cermak Road was demolished when a new freeway was built in the early 1960s. The association then moved to Wentworth Avenue. The next building on its right is the office of Chee Tuck Association for people of either the Wu, Zhou, Cai, or Ong family name. The Chee Tuck Association was already established in 1922. The Lung Kong Association, to the right of Chee Tuck Association, is another organization for several surnames combined. Won Kow Restaurant, at the far right, already in operation in the 1930s, is probably the oldest surviving restaurant in Chinatown, though under different management.

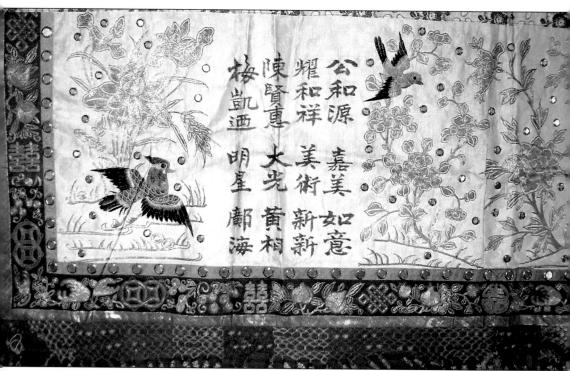

CHICAGO METROPOLITAN LEE ASSOCIATION HANGING. This beautiful eight-foot-long embroidered horizontal hanging was a joint gift from a group of businesses in Chinatown for the move of the association. While it is known that this gift dates from 1943 or later, the dedicatory text did not give specific dates.

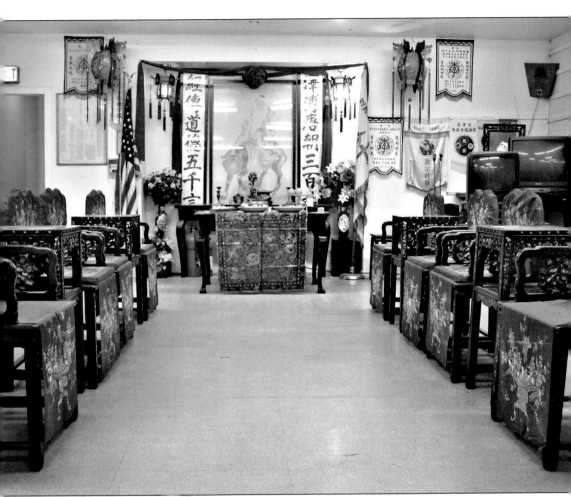

MAIN HALL OF THE CHICAGO METROPOLITAN LEE ASSOCIATION, 2005. The formal chair covers shown in this photograph are red with couched decoration in gold thread. Of museum quality, they are among the finest traditional Chinese textiles in Chinatown.

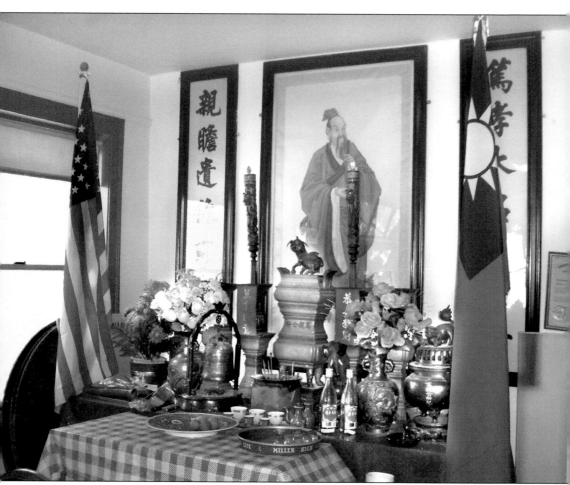

GEE KOW OAK TIN ASSOCIATION SHRINE, CERMAK ROAD, 2005. Established in 1906 at Clark Street, the association started as one for people of Chen, Hu, and Yuan surnames. The association moved and re-structured several times and settled at its current location in 1951. It honors the legendary emperor Yao as its patron saint.

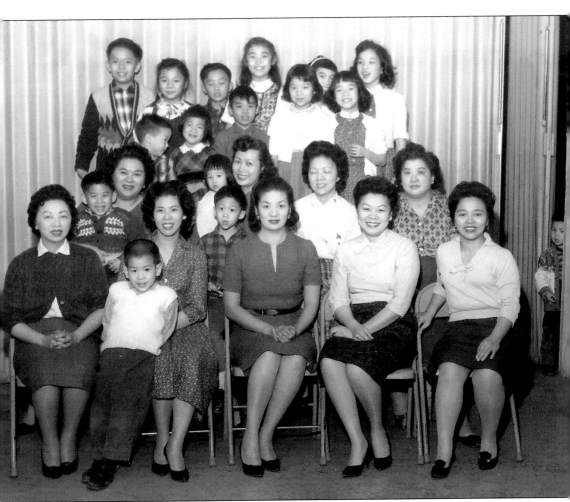

RELIGION: A POWERFUL BINDING FORCE IN CHINATOWN, CHICAGO, 1940s. The Chinese Christian Union Church on Wentworth provided important social and cultural functions to the progressive members of the community. The church has never stopped in expanding its services. Shown here is the Women's Club that met regularly to help out with the church events.

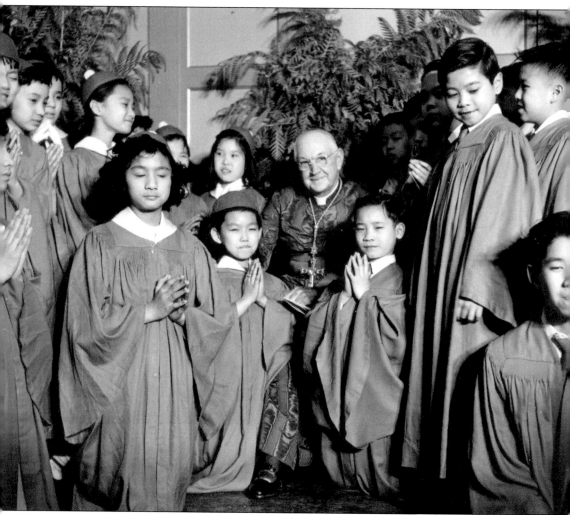

CARDINAL STRITCH OF ST. THERESE CHURCH, 1940s. The Catholic Church in Chinatown has been supportive to the community in many significant ways. Together the two churches did much good missionary work right here in Chicago's Chinatown.

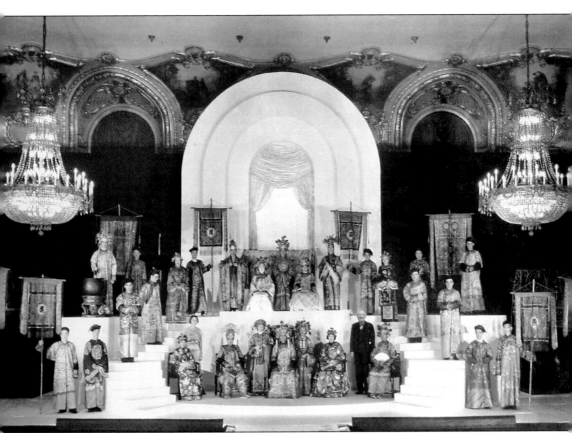

PARTICIPATING IN A LARGER COMMUNITY, 1920s. Cultural events in Chicago related to Chinese subjects drew support and attention to the Chinese immigrant community. In this picture one sees a large Qing imperial costume party hosted by the Beloit College. Among the many European models, there were unmistakably Asians. One imagines events like this must have heightened the cultural awareness among the community, not to mention that it was a lot of fun too.

To __ P. L. Prentis,

Chinese and Immigrant Inspector

Chicago, Illinois.

Sir: It being my intention to leave the United States on a temporary visit abroad, and to depart and return through the Chines_

port of entry of **Seattle, Washington,** , I hereby apply, under the provisions of the laws of the United State_

relating to the exclusion of Chinese (specifically Section 7 of the Act approved September 13, 1888), and of Rules 12 to 14 of th_ Regulations of the Department of Commerce and Labor drawn in conformity there_ with, for preinvestigation of my claimed status as a lawfully domiciled labore_

I submit herewith my certificate of residence, No.**8153.** (or _ certified transcript of a court record of my discharge as a person lawfully entitle_ to be in the United States). I am prepared to appear before you personally a_ such time and place as you may designate, and to produce at such time and plac_ witnesses to prove my statutory qualifications for a return certificate, as follows:

FAMILY:

Wife named

Residing

Child or children, named

Residing

Parent, named

Residing

OR

PROPERTY or DEBTS, or both (aggregating at least $1,000 in value) described as follows:

$525.00 Money loaned to Moy Jok, 515 So. Clark St., Chicago, Illinois.

$500.00 Money loaned to Charley Moy, 1939 Milwaukee Ave., Chicago, Ill.

I HEREBY AGREE that the above-described claims shall remain as they now exist until my return.

Signature in Chinese 梅土

Subscribed and sworn to before me, this

Signature in English _Moy Sue_

3rd day of **October** ,

c/o Hip Lung & Co.

Address 515 So. Clark St., Chicago, Illino_

A DOMICILED LABORER'S RE-ENTRY APPLICATION, CHICAGO, 1911. There were few Chinese women in America before 1945. Immigrants often went back to China to look for a wife. Moy Sue was one such young man. Dressed in the traditional Chinese clothes and with pigtail wrapped around his head, he was a lawful domiciled laborer. In order to secure his return entry to the United States, he submitted a certificate of residence and declared a personal asset of $1025. Like a few other immigrants, Sue's correspondence address was that of the well-known Hip Lung & Co (Figs. 56, 64, 66, 123) where a Moy Jok owned him a debt.

Four

A WORLD WITH FEW WOMEN
SOO LON MOY

Family life for early Chinese immigrants was very different from today. The Chinese Exclusion Acts had negative impacts on the traditional Chinese family. These laws prevented Chinese women from entering the United States, except for wives of merchants, students, teachers, and tourists. The procreation of a second generation was hampered since Chinese men were not able to bring their families with them. A new trend emerged for the Chinese immigrants. Early immigrants and their sons returned to China for arranged marriages. After the birth of one or two babies, they returned to America alone to continue working. A lucky few were able to bring their sons over by buying false certificates from American-born Chinese, enabling them to enter the U.S. legally. These sons would then return to China for marriage when they came of age.

Most men lived lonely lives, separated from their families. They worked hard and sent remittances to their parents and wives. Some families relied on the overseas wage earners for their living. Some were envious of the more affluent lives enjoyed by the overseas workers' families. But not only did the men lead lonely lives overseas, so did their wives in China. Wives took care of the children and parents-in-law. The name "gold mountain widows" was given to these women—the lonely existence, without the husband's presence, was like that of a widow. Since there were very few Chinese women in Chicago, some men married non-Chinese women, including Hawaiians, blacks, Polish, Irish, and others. Despite the severely limiting Exclusion Acts, there were still many whole families in the United States. These were mostly families of native-born Chinese, Chinese merchants, and other Chinese who were not restricted. These families thrived in the United States. Traditional Chinese culture, values, and language were taught not only in the homes but also in the Chinese language schools. Chinese festivals such as Chinese New Year, Harvest Moon Festival, and Ching Ming (Tomb Sweeping Festival in the spring) were celebrated. Later some families included American holidays such as Independence Day, Thanksgiving, and Christmas.

In traditional Chinese culture, education was highly valued. Chinese-American parents believed that education led to socioeconomic success for their children. Even though there were after-school Chinese language schools for the children to attend after the regular English schools, many parents chose to send their children back to China for a period of time for formal Chinese education.

After spending many years in China speaking and writing only Chinese, some children forgot their English, as in the case of Ruth Moy. In 1928, Ruth left for China when she was eight years old. She attended a regular village school with cousins and didn't use much English. Her mother wrote letters in English to her, but Ruth didn't have the opportunity to speak English for 10 years. In 1938, when she came back to the United States through Seattle, Ruth was detained as an immigrant even though she had citizen's papers. She couldn't answer any of the questions posed by the immigration officials in English. She felt like a new immigrant. Ruth was finally released through legal procedures initiated by her father (see page 88).

After the repeal of the Chinese Exclusion Acts in 1943, and the passing of the War Bride Act, the Chinese-American community was transformed from a bachelor society to one filled with families and children. Finally, Chinese Americans were given more rightful freedom of citizenship.

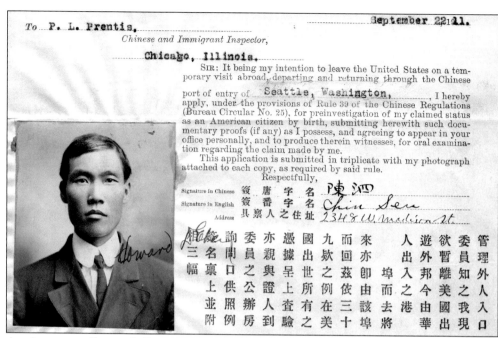

To P. L. Prentis,
Chinese and Immigrant Inspector,

Chicago, Illinois,

September 22, 11.

SIR: It being my intention to leave the United States on a temporary visit abroad, departing and returning through the Chinese port of entry of **Seattle, Washington,** , I hereby apply, under the provisions of Rule 39 of the Chinese Regulations (Bureau Circular No. 25), for preinvestigation of my claimed status as an American citizen by birth, submitting herewith such documentary proofs (if any) as I possess, and agreeing to appear in your office personally, and to produce therein witnesses, for oral examination regarding the claim made by me.

This application is submitted in triplicate with my photograph attached to each copy, as required by said rule.

Respectfully,

Signature in Chinese 簽 唐 字 名 陳泗
Signature in English 簽 番 字 名 Chin Seu
Address 具禀人之住址 2348 W. Madison St.

AN AMERICAN CITIZEN'S RE-ENTRY APPLICATION, CHICAGO, 1911. As an American citizen Chin Seu was not required to show proof of personal assets in order to return to the States. His application for citizenship was in English and Chinese. Like Moy Sue (see page 80), this young man was most likely traveling to China for an arranged marriage.

CHARLES K.S. LEE'S DIPLOMA FROM TEACHER PREPARATORY SCHOOL, GUANGDONG, 1914. This diploma was awarded to Mr. Charles Lee for completion of course work at the Teacher Preparatory School in Guangdong in February 1914. His official degree helped him secure a teaching position in San Francisco (see pages 21, 35).

CHARLES K.S. LEE'S EMPLOYMENT CONTRACT, SAN FRANCISCO, 1919. The San Francisco Chinese Consolidated Benevolent Association (also known as the Chinese Six Company) hired Charles K.S. Lee from Canton to teach Chinese at the association's language school. This contract states that Lee earned $50 a month between 1918 and 1919.

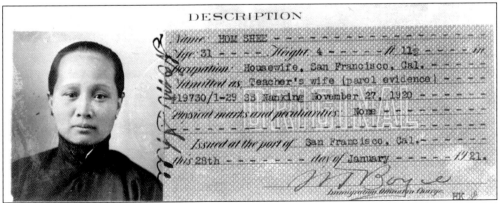

CERTIFICATE OF IDENTITY FOR HOM SHEE, SAN FRANCISCO, 1921. Bringing a wife and children to the United States was not easy for working-class Chinese immigrants. By contrast, spouses of teachers and other professionals found the procedure relatively simple; the Chinese Exclusion Act did not impact them. Hom Shee, wife of Charles K.S. Lee (see page 21) was issued a U.S. government certificate of identity in January 1921. Her husband came to America as a teacher. Early 20th-century documents often recorded the natal surname of Chinese women. Hom was this woman's last name; "Shee" merely means "a person."

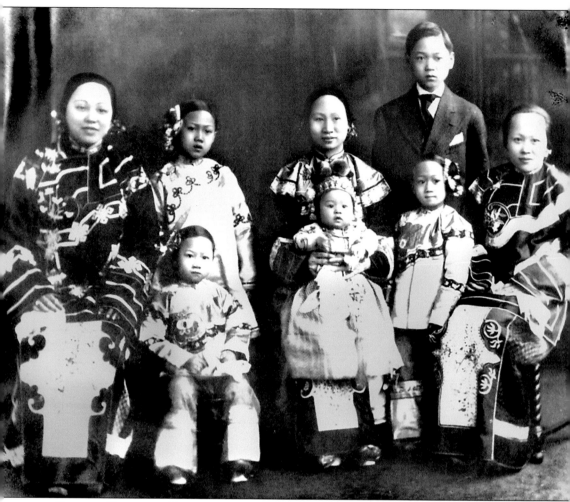

DYNASTY BUILDERS: FAMILIES OF THE THREE MOY BROTHERS, CHICAGO, 1910S. A century ago, the Moy family was the largest and most influential in Chicago. Like all immigrants, they regarded the traditional festivals as time to reassert their native identity. Here their wives and children—except Fook Cheung, dressed in a western suit—wear 19th-century Qing dynasty style (AD 1644–1911) outfits. Platform shoes, although worn primarily by Manchu women in China, were favored by Cantonese in America. From left to right, these women are Mrs. Dong Yee Moy, Mrs. Dong Chow Moy, and Mrs. Dong Hoy Moy (see pages 50, 61).

THE SECOND GENERATION, CHICAGO, LATE 1910S. Lillian, the first Chicago-born daughter of Moy Dong Chow, married Yusheng Wong, a visiting student from China. They eventually re-settled in China, where Yusheng achieved a high-level government position.

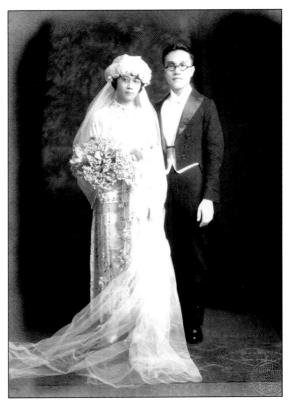

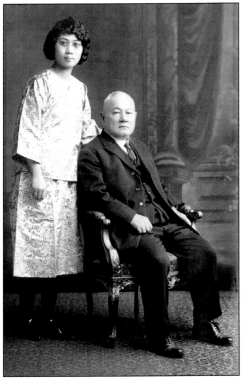

MOY DONG CHOW AND DAUGHTER LILLIAN, CHICAGO, C. 1925. Credited as the founder of Chinatown in Chicago and recognized in his funeral eulogy to be the wealthiest Chinese in America, the 80-year old Dong Chow poses here with his daughter Lillian. Like her other siblings, Lillian received a college degree from the University of Illinois, Champaign. She prepared for China to build a career. She never returned to Chicago, probably because her immediate family no longer lived here. Dong Chow died two years after this photograph was taken (see also page 61).

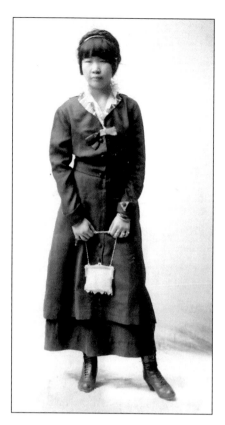

ANOTHER CHINESE-AMERICAN FAMILY: THE TOYS, BENTON HARBOR, MICHIGAN, 1917. Born and raised in Walnut Grove, California, Ellen Lee was only 15 years old when the arranged marriage was made for her and Toy Gow. Gow was a farmer in Benton Harbor and a new immigrant more than 30 years her senior. Here the fashionably dressed 17 year-old young mother looks happy (see also pages 33, 87).

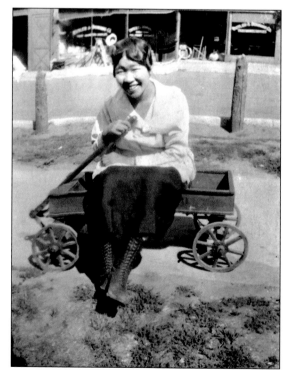

A HAPPY YOUNG MOTHER, BENTON HARBOR, MICHIGAN, 1919. Arranged marriages could lead to happy endings. Ellen and Gow Toy raised five children and enjoyed a pleasant retirement in Chicago. Ellen took time out to relax with her husband from their two businesses in Michigan—a laundry and King Joy Lo Restaurant.

SASSY AND CONFIDENT YOUNG LADY, BENTON HARBOR, 1920S. Ellen Lee Toy grew to be a handsome young woman. She is posed confidently in her new outfit with braided hair wrapped around her head. She later opened an antique shop in Benton Harbor that sold American second-hand merchandise.

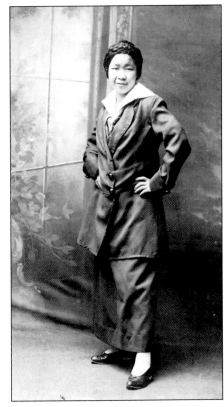

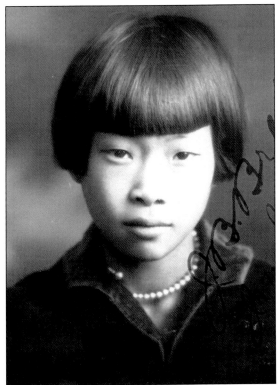

THE YOUNGER ELLEN TOY, BENTON HARBOR, MICHIGAN, 1926. Immigrant parents sent their children back to China to receive formal Chinese education as well as to spare the parents time to make a living. Ellen Toy, the first girl of Ellen and Gow Toy, went to Taishan (Toisan) with her two younger siblings. Ellen stayed there for 10 years. Although Chinese immigrants customarily left their children in the care of relatives in China, this arrangement could not have been easy for the children involved. Ellen returned to Michigan and then moved to Chicago as a frustrated young adult. Like many children of expatriates, Ellen did not enjoy her change of living environment and perhaps even more, growing up without parental attention.

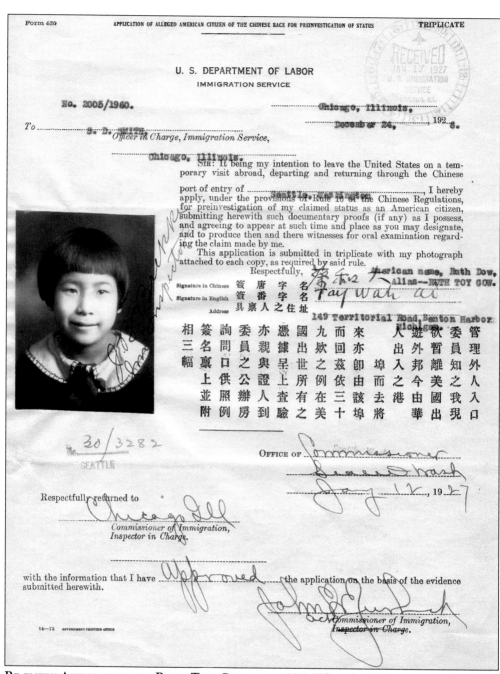

U. S. DEPARTMENT OF LABOR
IMMIGRATION SERVICE

No. 2005/1960. Chicago, Illinois.

Received JAN 17 1927 U. S. IMMIGRATION SERVICE

December 24, 192 6.

To S. D. SMITH

Officer in Charge, Immigration Service,

Chicago, Illinois.

SIR: It being my intention to leave the United States on a temporary visit abroad, departing and returning through the Chinese port of entry of Seattle, Washington, I hereby apply, under the provisions of Rule 16 of the Chinese Regulations, for preinvestigation of my claimed status as an American citizen, submitting herewith such documentary proofs (if any) as I possess, and agreeing to appear at such time and place as you may designate, and to produce then and there witnesses for oral examination regarding the claim made by me.

This application is submitted in triplicate with my photograph attached to each copy, as required by said rule.

Respectfully,

American name, Ruth Dow, Alias--RUTH TOY GOW.

Signature in Chinese

Signature in English Fay Wah Au

Address 149 Territorial Road, Benton Harbor Mich.

No. 30/3282 SEATTLE

OFFICE OF Commissioner

Jan 17, 1927

Respectfully returned to Chicago, Ill.

Commissioner of Immigration,
Inspector in Charge.

with the information that I have Approved the application on the basis of the evidence submitted herewith.

Commissioner of Immigration,
Inspector in Charge.

14—73 GOVERNMENT PRINTING OFFICE

RE-ENTRY APPLICATION FOR RUTH TOY, CHICAGO, 1926. When the Michigan-born Ruth Toy applied for a re-entry permit before leaving for China, she was only eight years old. Together with her older sister Ellen and one brother, she spent the following decade with her father's relatives in their village. Although such arrangements puzzled American friends, her parents were convinced that their three children would be safe even though there was political unrest in some parts of China. They sailed for China in 1927. Their mother, whose Chinese was elementary, wrote letters to the daughters in English that Ruth could not fully understand. In her words, "I was born again several times. Once to go to China and once to return to Chicago."

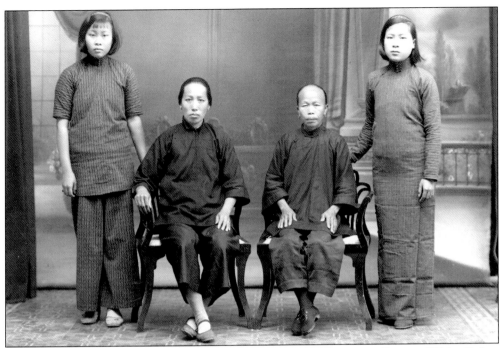

Growing Up in China for American-Born Chinese, Taishan, China, 1930s. Before returning to the United States, Ellen and Ruth Toy posed for pictures with a favorite aunt and their father's first wife. Although growing up without their mother was difficult, Ruth was glad that she had the opportunity to learn about the "other family" and to acquire a fluent Taishanese dialect to speak with her father. She also learned to read and write Chinese. Ruth has been living in Chicago since 1938.

Toy Gow and Owl "Ge Gi," Benton Harbor, Michigan, 1940s. Gow made the news when he caught a big horned owl with his bare hand. He heard a racket in his chicken coop and discovered that the owl had killed six or seven of his chickens. Gow made a wire cage for the owl and vowed that "Ge Gi" would pay for killing his chickens. He placed the owl next to his roadside vegetable stand as a way of attracting customers' attention.

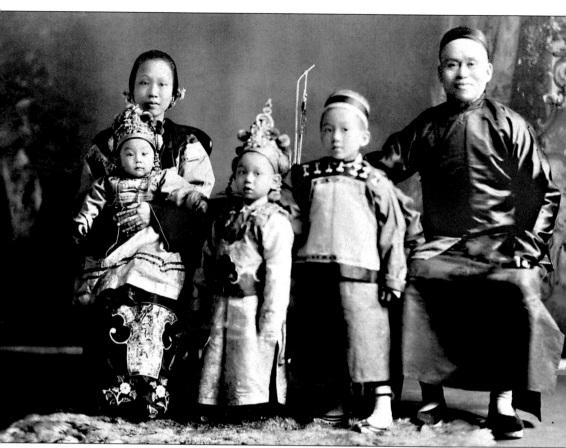

To Live Together or Separately? A Hard Decision. Chicago, 1908. Immigrant families broke up for a number of reasons. Here is Moy Foot, a wealthy merchant, who was about to take his wife and children back to China. The photograph, used for his re-entry application, was taken in Chicago—probably for a New Year celebration. The couple was married in San Francisco in June 1901; their three sons were born in Chicago between 1902 and 1907. His wife, Chin Gay Moy, was then 1 of the 20 Chinese women living in Chicago. Their portrait, taken for this journey, would be the only one of the couple shown together, as well as their only one with their sons. Moy Foot and Chin Gay spent at least one third of their married life living separately.

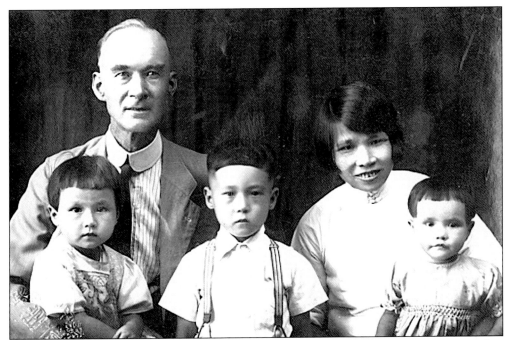

A Successful Biracial Marriage, China, 1936. Mixed marriages were uncommon but not unknown in early 20th-century China. Missionary R. Paul Montgomery, a native of Yates City, Illinois, and a graduate of the McCormick Seminary in Chicago, married a local woman doctor in Sanjiang, Guangdong. As his church did not approve cross-cultural marriages, Paul permanently left the mission. He built a family and taught at several schools in the Sanjiang area before bringing his family to America in the 1940s (see page 23). Their oldest daughter, Margaret (far left), now resides in Evanston.

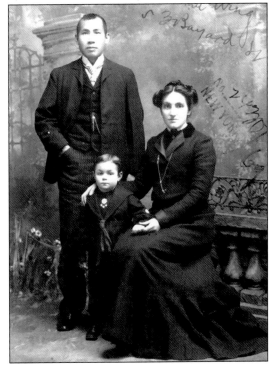

An Unsuccessful Biracial Marriage, Chicago, 1914. Emma Sizer worked as a kindergarten teacher and lived in New York's Chinatown. She was fluent in Chinese. Willie Wing was illiterate in English and lived in Chicago. The two married and adopted a Jewish boy. They traveled to Hong Kong where Emma discovered that Willie had two other wives. The angry Emma returned to New York and asked the Immigration Department to deport Willie. Her credibility was ruined when the Immigration Department learned that Emma had been legally married to another man when she married Willie Wing. The Immigration Office could not prove that Willie was here illegally so he was not deported.

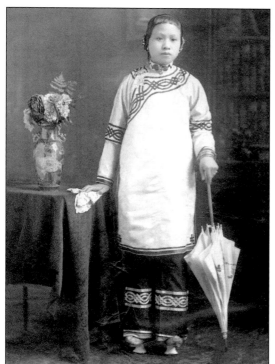

FASHIONABLE YOUNG LADY, CHICAGO, 1900S. Adjusting to the lifestyles and values of a new culture is a constant challenge for immigrants. Wu Tingfang, the Minister of Foreign Affairs for the Provincial Government of the Republic of China, spent several years in Europe and the U.S., and wrote in 1914, "I do not contend that the Chinese dress is perfect, but I have no hesitation in affirming that it is more comfortable and . . . very much prettier than the American fashions." Shown here is a young Chicago lady dressed in Qing dynasty clothing holding a parasol. Oral history in Chinatown observes that early 20th-century wives and daughters made their own ethnic clothing.

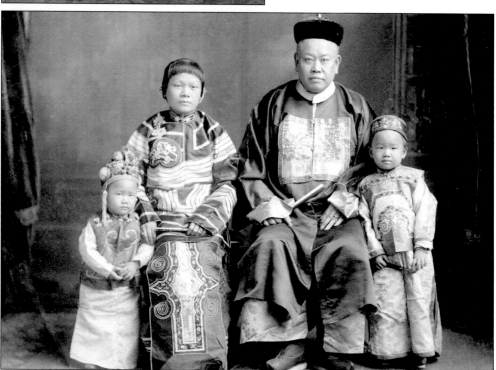

FAMILY PORTRAIT, CHICAGO, 1900S. Clothing is a powerful way of telling people who you are. This family, shown here in their finest Qing dynasty clothing, probably posed for a festival celebration. Many families customarily sent such photographs home to relatives in China.

GARMENT FOR A LITTLE BOY, CHICAGO, 1900S. Here is a handmade, typical traditional Chinese pant style with an open crotch for boys. Designed for ease and comfort, the open crotch pant eliminates the need for diapers. This style continues to be popular in some areas of modern-day China.

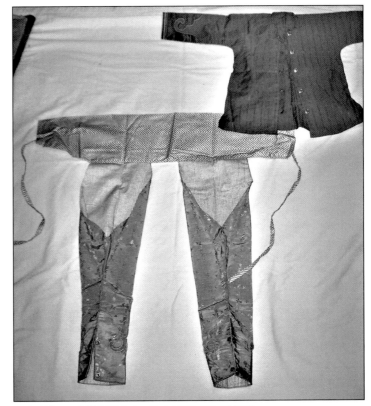

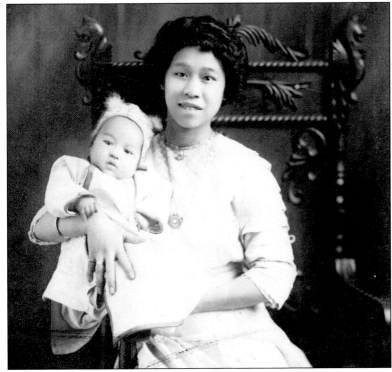

PROUD MOTHER, CHICAGO, 1910S. A proud mother in western dress holds up her precious baby for the world to admire.

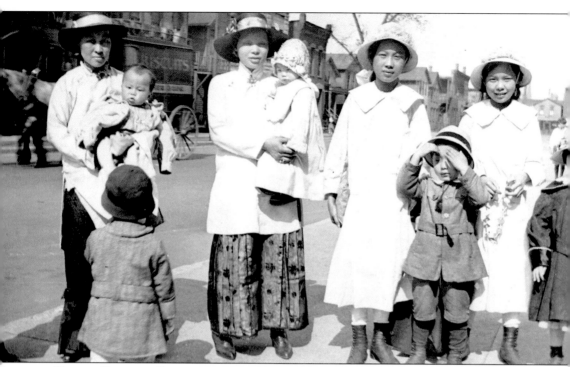

EASTER OUTFITS, CHICAGO, 1920S. Four young mothers and their children, all dressed in their western-style Sunday finery, pause for a group photo before attending church, possibly on Easter Sunday.

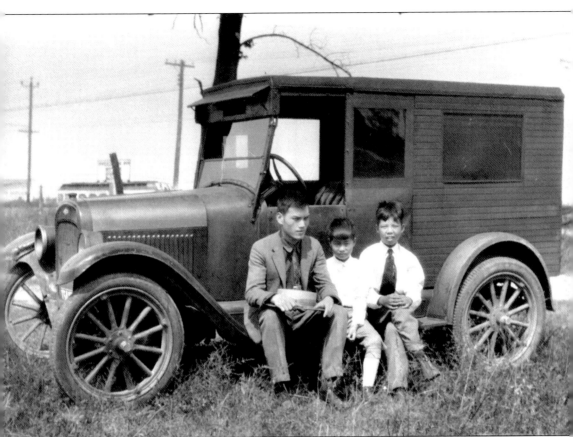

Tom Chan the Mechanic, Marion, Indiana, 1919. Tom Chan (Siu Jon) came to the U.S. as the 17-year old son of a laundry owner in Indiana. He was not only an experienced pilot, but was also a fine mechanic and craftsman. Here he is pictured with his son, Gene, and a cousin, sitting on the running board of the Ford car, the top of which he built out of wood. This Tom Chan is not to be confused with another Tom Chan, who was a serious politician (see page 63).

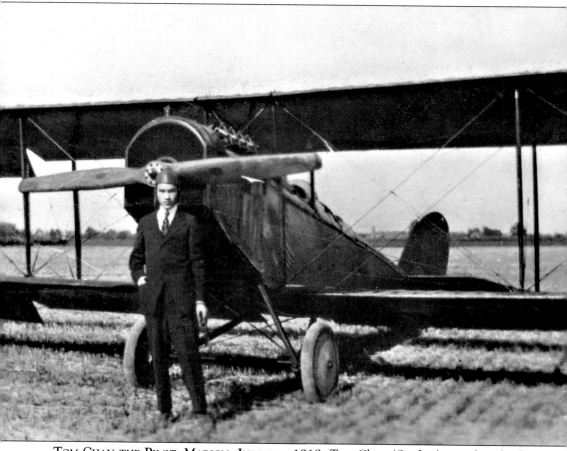

Tom Chan the Pilot, Marion, Indiana, 1919. Tom Chan (Siu Jon) signed up for flying classes after he bought his Ford car. Standing in front of his small biplane, he looks very confident. Mr.Chan was one of the first Chinese pilots in the Midwest.

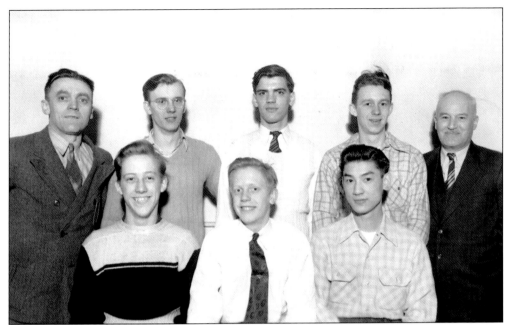

ILLINOIS STATE "B" CHAMPS, CHICAGO, 1944. Many Chinese youngsters participate in sports outside of schools. Gene Kung, whose father was Tom Chan the pilot (see page 96) came to Chicago as a "paper son." Gene grew up to become an American. He joined the basketball team from the North Avenue YMCA, which won the Illinois State "B" Championship in 1944.

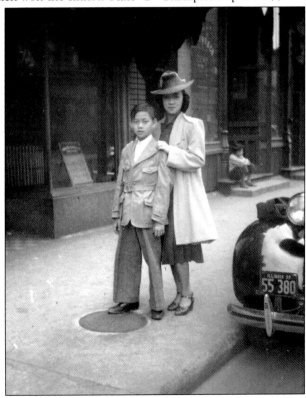

MOTHER AND SON, CHICAGO, 1940s. This mother, Jean Moy and her son, Corwin, posed for the camera in their finest western Sunday garb.

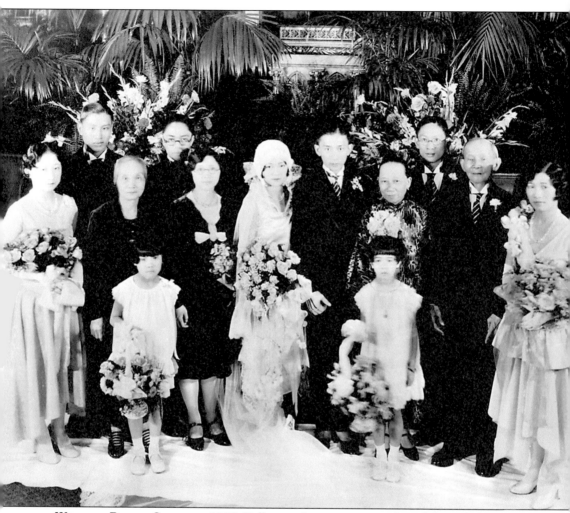

WEDDING PARTY, CHICAGO, 1929. Different ethnic groups may dress differently for a wedding, but the essence of the occasion is universal: families get together to witness the event. This wedding photograph shows a large extended family gathered to help celebrate the happy event with the bride and groom.

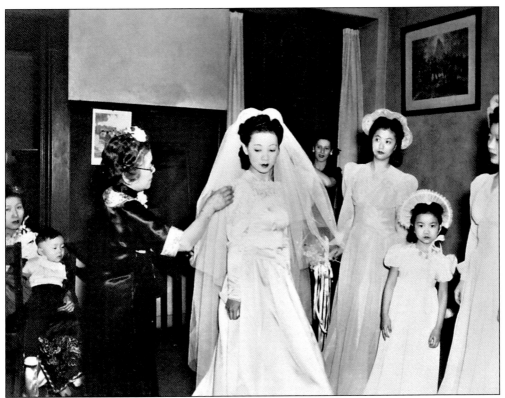

WEDDING DAY, CHICAGO, 1940s. On this happy wedding day, a relative lovingly straightens the bride's veil as the bride's maids look on. For an American-style wedding, the Chinese bride and her family do not mind that the bride dresses in white, a color that the Chinese usually consider unlucky.

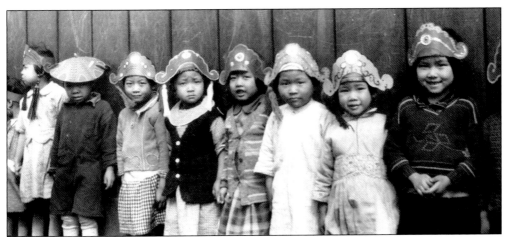

JOHN C. HAINES SCHOOL—KINDERGARTEN CLASS, CHICAGO, 1931. School children of the 1930s will fondly remember Miss Olga Huncke. This dedicated kindergarten teacher taught at John C. Haines School in Chinatown for many years. She promoted Chinese culture and instilled cultural pride in the children. Here a group of happy girls show off their Chinese headwear.

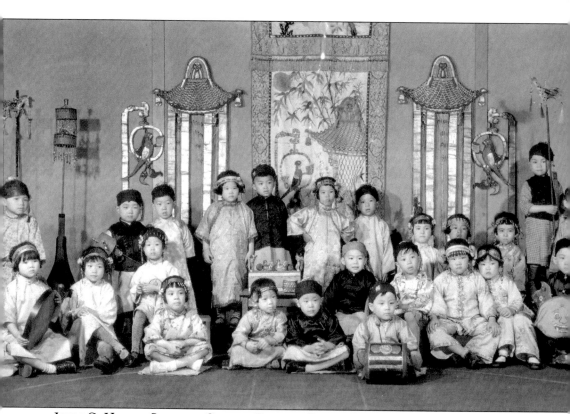

JOHN C. HAINES SCHOOL—CHINESE RHYTHM BAND, CHICAGO, 1932. What made Haines School special to many Chinatown children was Miss Olga Huncke's cultural-specific programs for the Chinese students. Here they are dressed in their ethnic costume on a Chinese-décor stage. It was a performance put together by Miss Huncke, a devoted kindergarten teacher who helped to instill cultural pride in her students.

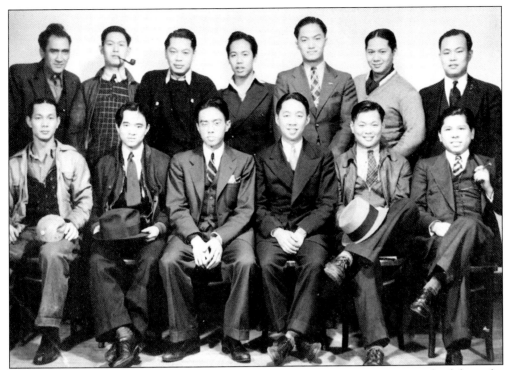

FASHIONABLE AND SUCCESSFUL YOUNG MEN, CHICAGO, 1930S. Sam Moy, third from the right in the front row, poses with a group of his friends. Dressed in western garb, these young men appear confident and successful.

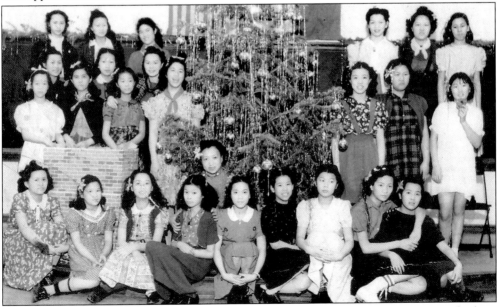

CHINESE GIRL SCOUT TROOP—CHRISTMAS PARTY, CHICAGO, 1944. Scout troops for boys and girls have been serving the Chinatown community for many years. Youngsters learn life-skills, make new friends, and have fun. Here Mrs. Goo, the Girl Scout leader, hosts a Christmas party in 1944 for her troop.

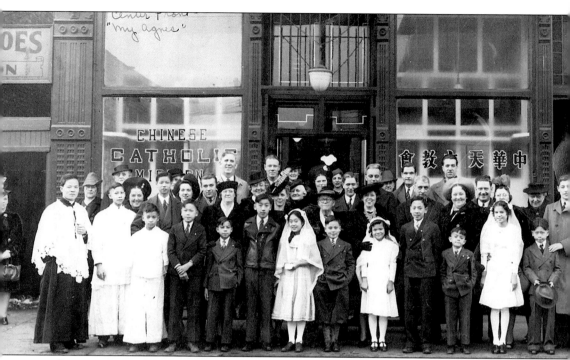

CONFIRMATION CLASS, CHICAGO, 1947. A large confirmation class celebrated the event at the Chinese Catholic Mission on Wentworth Avenue in Chinatown with classmates, families, and friends. In addition to the American schools and the after-school Chinese language schools, churches also provide education for the Chinese families. Father Mao, the first Chinese-speaking priest for the church, is the first person on the far left.

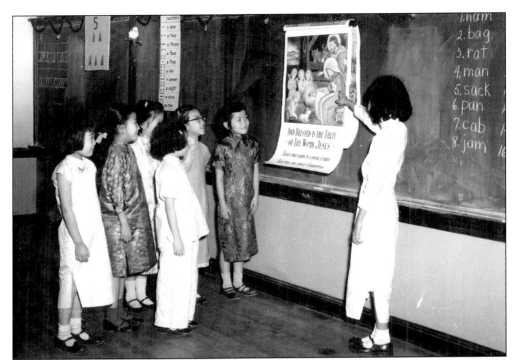

First Grade Classroom in St. Therese School, Chinatown, Chicago, 1956. Dressed in traditional Chinese garb, the teacher and girls posed for a photograph. St. Therese School, established by the Chinese Catholic Mission and St. Therese Church, serves students of Chinese ancestry from kindergarten through eighth grade.

Chinese New Year Celebration, Chicago, 1956. Like Haines School in the neighborhood, St. Therese School also embraces Chinese traditions. The school maintained cultural-oriented interest groups such as a Lion Dance Troup. Here some young men of the Troup welcome the Chinese New Year with the traditional lion dance—an act to chase away evil spirits and bring good luck. Early Chinese immigrants brought this special custom with them to America.

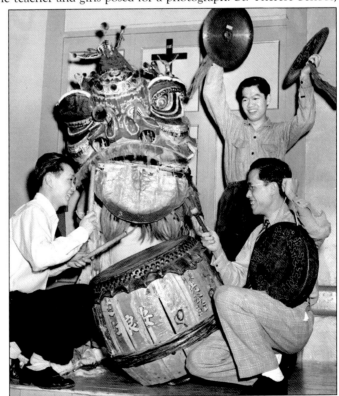

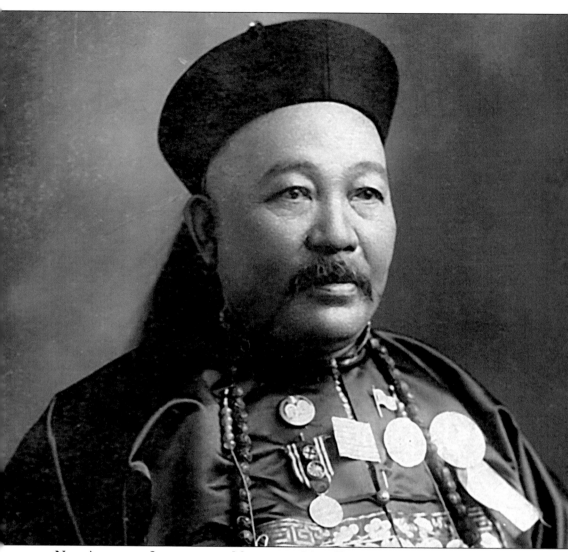

NON-AMERICAN INDIANAPOLIS MERCHANT MOY KEE, 1906. Moy seems to have been a showman. This photo is from an Immigration Bureau document. It was not necessary and perhaps unwise to present oneself to the Immigration Bureau as being so obviously un-American. Further, most of the medals and pins Moy is wearing are American, although the imperial official's necklace and robe with rank badge are Chinese enough. He chose to show off his Chinese identity at a time when most Chinese preferred to downplay it.

Five

BECOMING AMERICAN
BENNET BRONSON

Chinese in the western states had a bad time between 1870 and 1900. There were numerous anti-Chinese riots, several massacres, and many robberies. There were also many unjust local laws. So many Chinese fled east, to cities like Chicago.

Here they felt more welcome, but they laid low anyway. The first sign that Chicago's Chinese felt secure enough to show a higher profile came in 1893, at the biggest and most successful world fair ever held in any city, the World's Columbian Exposition.

The Chinese government had refused to take part as a protest against the Chinese Exclusion Laws of the 1880s. However, a group of local Chinese businessmen felt that China had to be represented anyway. They formed an ad hoc company, the Wah Mee Corporation, and built their own exhibition. Their Chinese Theater and Joss House, with its own restaurant, was a success. Hundreds of thousands of European-Americans had their first taste of Chinese food there and their first views of Chinese culture. Many Chinese came from all over the U.S.

Already there were calls for Chinese to make themselves more visible and to claim their rights as American citizens (when born here) and residents. In the 1910s, the restaurant owner Chin Foin made a well-publicized attempt to move his family into a middle-class neighborhood where only European-Americans lived. With the support of several Chicago newspapers he succeeded.

In 1933, Chicago's Chinese became deeply involved in the second great world fair held here, the Century of Progress Exposition. The Chinese government participated officially, and Chinese from Chinatown, only a short walk from the fair, attended in large numbers. Their involvement peaked in a major parade held on October 1. The whole of Chinatown turned out. With floats, bands, boy scouts, and pretty girls in Chinese costume, the parade was a great success. It was the first time that the full Chinese community of Chicago had asserted itself as the equal of every other ethnic community, parading in front of other Chicagoans and visitors from the entire world.

More parades outside Chinatown occurred in the late 1930s, as Chinese-Americans protested Japanese attacks on China. When Japan attacked the United States as well, on December 7, 1941, Chinese-Americans responded by affirming their willingness to fight for their adopted country. European Americans responded favorably to this and to publicity about China's brave stand against its attackers. For the first time, many European-Americans saw Chinese-Americans not as alien cooks and laundrymen but as allies and even friends. They were impressed, and Chinese-Americans were proud.

It was no accident that the Chinese Exclusion Laws were repealed while World War II still raged, in 1943. It would be many years before Chinese Americans attained real equality, and anti-Chinese racial prejudice still exists nowadays. But 1943 marked a turning point in the struggle to be accepted, politically and socially, as true Americans.

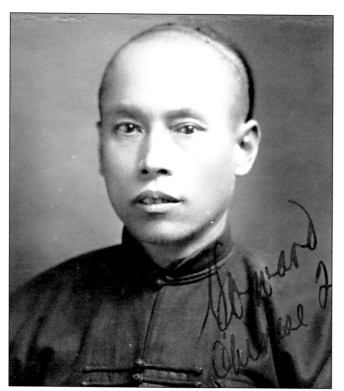

NON-AMERICAN ILLEGAL IMMIGRANT ENG YOU LEE, 1905. Arrested for illegal border crossing in 1905 in Detroit, Lee proved himself to be a native-born American and thus was acquitted of any crime. Eng's hairdo is not that of a native-born citizen, however. Wrapped around his head is a pigtail of the kind that the Manchu imperial government required all men to wear. The fact that he kept his pigtail shows that he planned to go back and live in China some day.

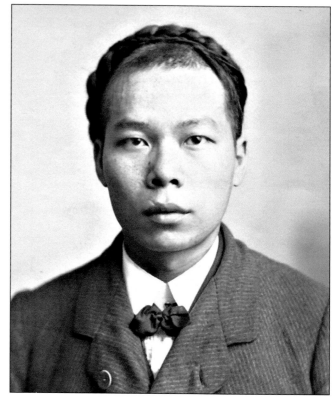

SEMI-AMERICAN CHICAGO MERCHANT MOY POY, 1911. Part-owner of Lee Lung & Co., a shop at 531 S. Clark Street in Chicago, Moy had already proven his citizenship when this picture was taken for Immigration. However, he too seems to have had a Chinese-style hairdo until very recently. The front half of his head is shaved, as was always the case when wearing a pigtail. Chinese men cut their pigtails off at the time of the anti-Manchu revolution. He seems to have done that, but the front of his head and his jacket still look more Chinese than American.

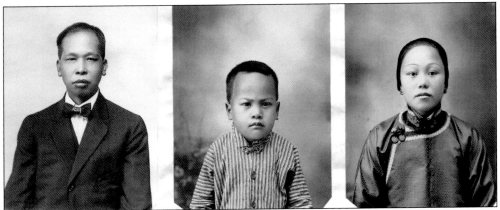

SEMI-AMERICAN CHICAGO MERCHANT LEE YOU SAM AND FAMILY, 1912. Lee owned a store in Chicago, Kut Chong Hing & Co., for at least 10 years. He seems to have been successful and to have made enough money to think about bringing his wife and son to Chicago to live with him. These pictures are from his family passport application. The wife and son, Leong Shee and five-year-old Lee Deng You, were still in China then. She is dressed in purely Chinese fashion, while their son is already wearing an American shirt and haircut.

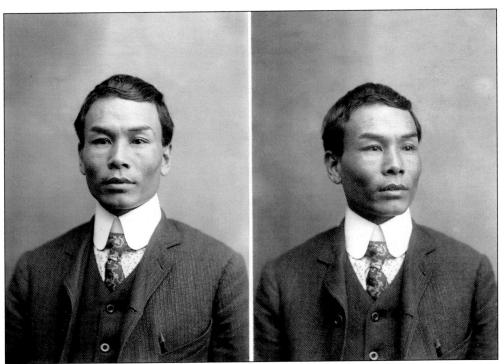

ALL-AMERICAN ILLEGAL IMMIGRANT JOHN MAR, 1906. Here is another Chinese man caught being smuggled over the U.S.-Canada border near Detroit. Unlike Eng You Lee (see page 106), however, Mar has an American haircut and is wearing a well-tailored American suit. He is recorded to have spoken very little English in spite of his appearance and Christian name. He also reacted passively to his arrest and—unlike many illegal immigrants—allowed himself to be deported without protest.

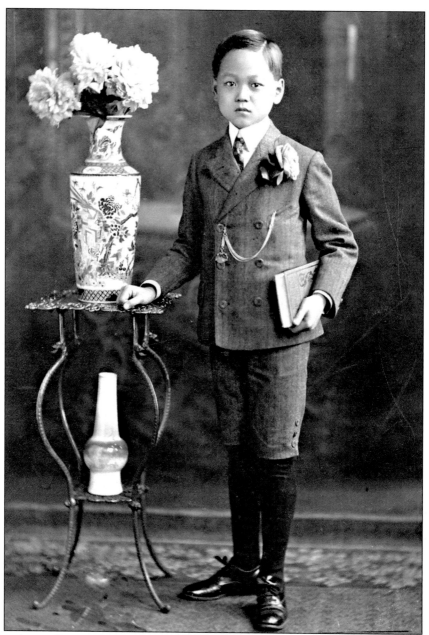

ALL-AMERICAN BOY WITH FLOWERS, 1910s. This boy is standing next to a vase on a small table, as is the case with thousands of other traditional Chinese portraits. But his costume is not at all Chinese. The book suggests that he is a studious lad. The gold watch chain is pretentious, but 100% American—similar watch chains appear in many European-American portraits of the same period.

This photograph represents the gradual acculturation of many Chinese immigrants. Fook Cheung, for example, was brought up in a progressive family. He was the first son of Dong Hoy Moy (see page 84), and his parents probably wished him a very American future. Fook Cheung later married a Chinese lady with bound feet. She stopped binding her feet after reaching Chicago.

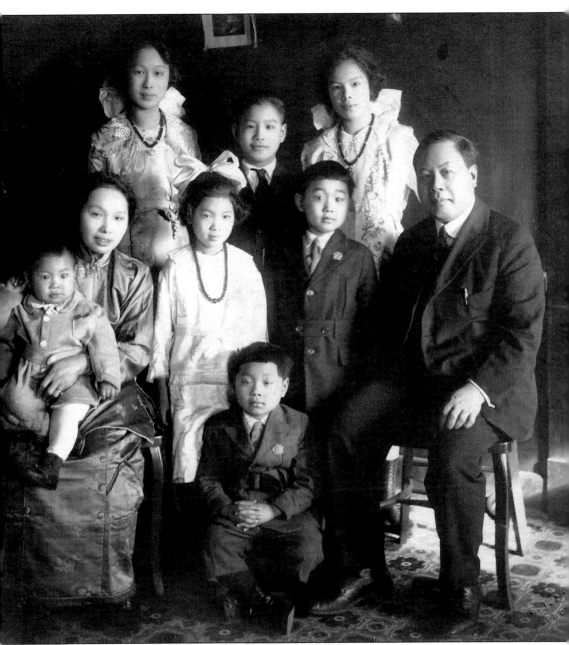

ALL-AMERICAN FAMILY, 1920S. That the children all look like one another leaves us in no doubt that they are brothers and sisters, with their father on the right and their mother on the left. The mother is the only one wearing Chinese clothes, a satin jacket and skirt with an unusual double-buttoned panel that she may have designed and sewn herself. The girls with their World War I-era dresses and the boys with their Norfolk jackets are dressed quite well and expensively in a purely American style.

THE MIDWAY OF THE WORLD'S COLUMBIAN EXPOSITION, 1893. The mile-long stretch known as the Midway, just outside the grounds of the official part of the Exposition, was entirely commercial, often vulgar, and immensely popular. The world's first Ferris Wheel is shown, end-on, in the distance. The Chinese Theatre and Temple appears just to the left of the Ferris Wheel. It was the first public display of Chinese culture (that is, food, drama, and religious art) ever held in the Midwest.

ARCHITECTS' DRAWINGS FOR THE CHINESE THEATRE AND TEMPLE, 1892. Because China was boycotting the Exposition, the Theatre and Temple had to be built by local Chinese businessmen without government support of any kind. They set up a special company, the Wah Mee ("Chinese American") Corporation, and hired a European-American architectural firm, Wilson and Marble, to produce a design. As is evident, the architects did not know much about Chinese architecture—the structures behind the towers look more Thai than Chinese. But no one seems to have minded.

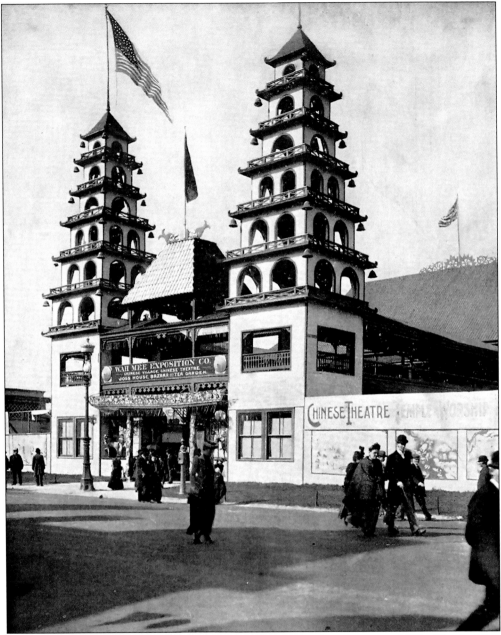

THE CHINESE THEATRE AND TEMPLE AS IT ACTUALLY APPEARED IN 1893. The builders followed the architects' plans quite closely, thus guaranteeing that Midwesterners would get a somewhat peculiar idea of the architecture of China. A café and large gift shop were attached to the theater and temple complex. One of the two earliest Chinese restaurants in the region, the café served American ham sandwiches and oatmeal as well as lychee fruit, "Longsoy" and "Syie Seen" tea, and "Chinese style" rice.

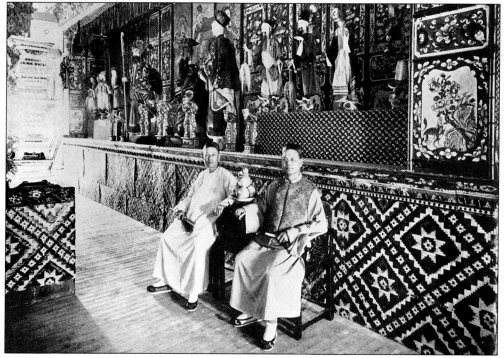

THE CHINESE JOSS HOUSE TEMPLE. Unlike the exterior of the temple and theater complex, the interior of the joss house must have had a real Chinese designer. It was a functional temple laid out in a traditional way, even though the black-and-white mats used as skirts for the tables and altars must have looked rather strange to most Chinese who saw them. Again, there was

no compromise when it came to presenting the essentials of Chinese culture. The alters even were furnished with fortune-telling sticks (currently in Chicago's Field Museum), although we do not believe that white visitors ever knelt down to throw the sticks in the floor and have their fortunes told.

CHINESE THEATRE PROGRAM. The theater on the Midway staged a play that featured a sword fight between two princesses—undoubtedly the first Chinese drama ever staged for Midwestern white audiences. Those audiences appear to have been fascinated to find that women's roles were played by men, as was customary in China. The proprietors took their mission seriously of showing Chinese culture off to their non-Chinese neighbors. They were willing to compromise for European-American values in such things as ham sandwiches—but the plays, costumes, and actors were real.

PERFECT AMERICAN CHILDREN, C. 1920. All dressed in white clothes like uniforms, there is nothing Chinese about the children's outfits or background. Most or all would soon be sent back to China, but the photograph gives no hint that their future is anything but pure European-American.

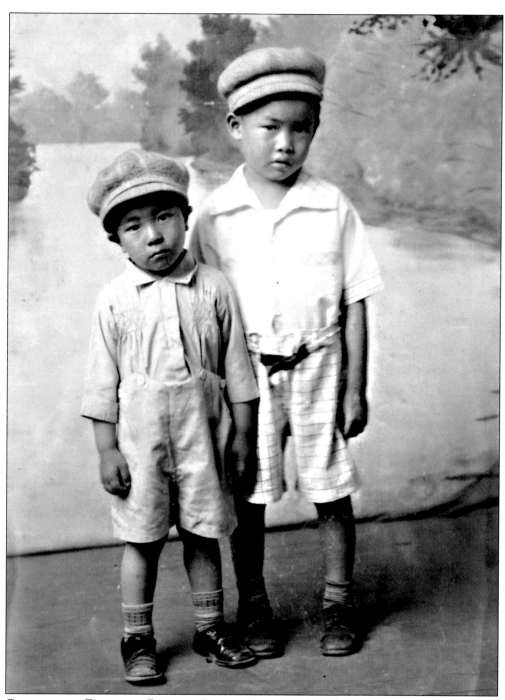

CHILDREN IN FRONT OF PAINTED LAKE, C. 1920. These boys, too, are dressed in pure European-American style, although they are somewhat less starched and clean-looking. The backdrop depicts a lake and trees—a scene that could be at any of the then-popular summer resorts in Wisconsin or Michigan. Chinese Americans visited such resorts in spite of the prejudiced attitudes of many rural Midwesterners. In later decades, Chinese family camps at similar resorts were supported by parents as places for Chinese boys and girls to meet.

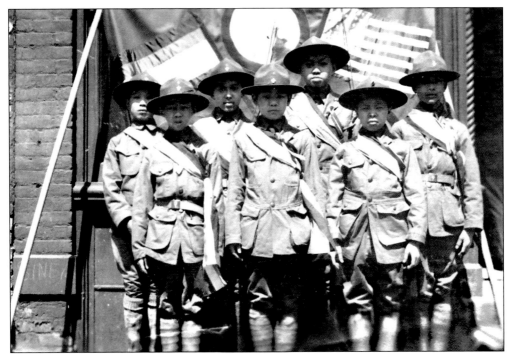

CHINESE BOY SCOUTS, CHICAGO, 1920S. Similar uniforms were worn by Boy Scouts everywhere in North America and Britain. The presence of Boy Scouts in the Chinese community marked a serious commitment to assimilation and good community relations. Most up-and-coming ethnic neighborhoods had Boy Scout troops. It was important for Chinatown to have them too.

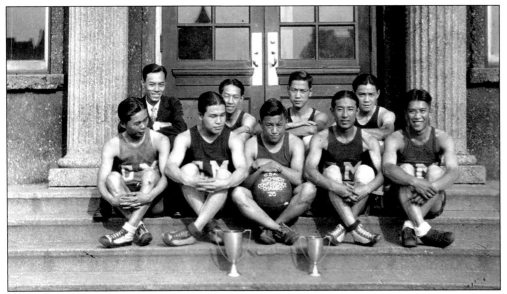

BASKETBALL CHAMPIONS, CHICAGO, 1926. In the 1920s and 1930s, basketball was a popular sport among Americanized Chinese. This team from Chicago's Chinatown traveled all over the country, mainly playing other Chinese-American teams. The words on the ball are "CSA Mid-West Conference Champs '26."

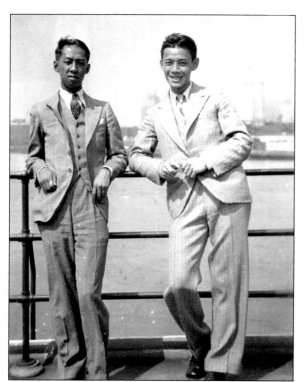

YOUNG MEN ON LAKE MICHIGAN CRUISE, CHICAGO, 1930S. Popular American media of the period often featured shipboard parties for upper-class youth. In these and the next few pictures, Chinese Americans clearly are influenced by images from newspapers, magazines, and silent films.

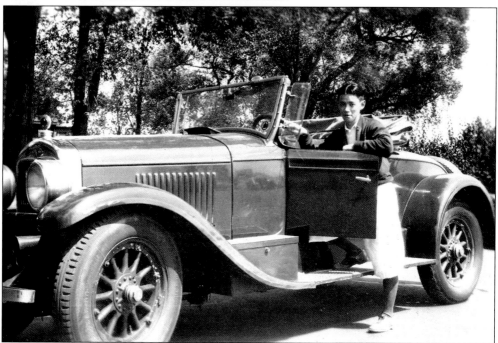

CAR AND DRIVER, CHICAGO, 1920S. The motoring trousers, the pose, and the car itself look as though they were taken from an advertisement. In the Midwest, as elsewhere in North America, young and wealthy (or would-be wealthy) Chinese seem to have bought whole-heartedly into American consumer culture.

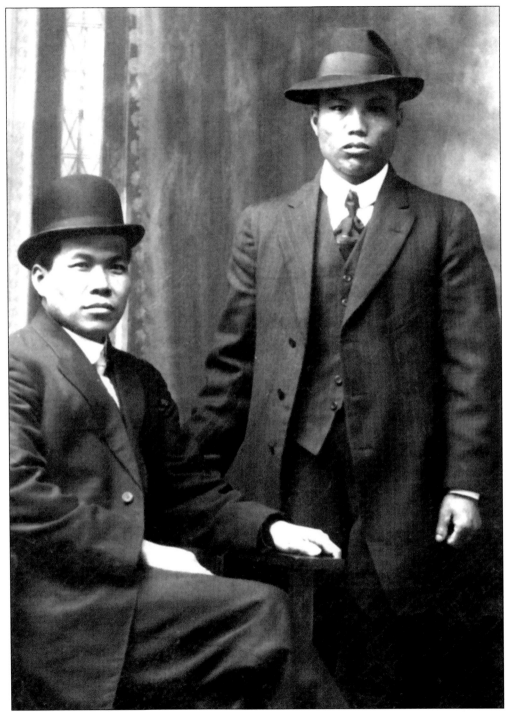

MEN IMITATING GANGSTERS, CHICAGO, 1920S. One of these men is Toy Gow, a law-abiding vegetable farmer from Michigan with a lively sense of humor. His companion was undoubtedly no more a gangster than Toy. Their tough-guy look is interesting even though it is just a pose. As in the case of the preceding image, it shows that Chinese Americans saw many movies.

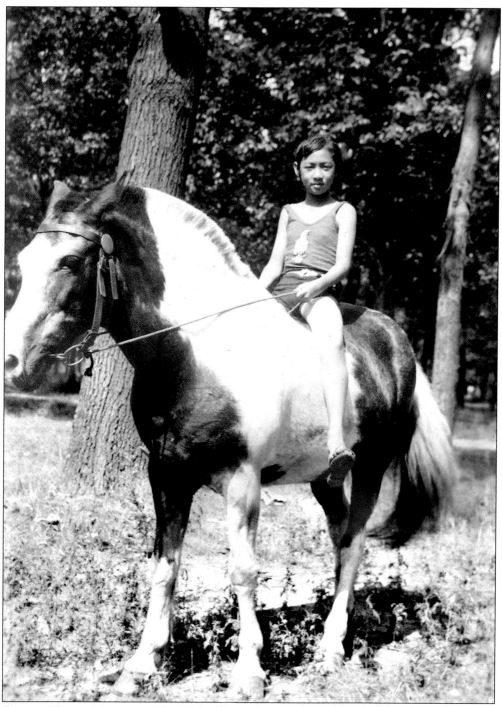

GIRL ON HORSE, MICHIGAN (?), 1920s. The girl has not been identified, but she is doing what countless other American girls were doing and dreaming of doing—riding a horse. American girls read and re-read popular teenagers' horse novels like *Black Beauty*. Chinese-American girls seem to have read and re-read those novels too. The girl in this case is riding bareback without stirrups or a saddle.

GIRLS IN FLAPPER OUTFITS, CHICAGO, 1920s. Cloche hats and short skirts—the outfits of the fashionable girls called "flappers" by the press—would have been impossibly scandalous in old China. In America, it was the way girls were expected to behave.

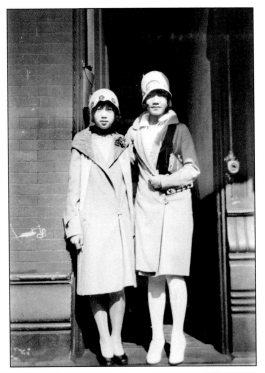

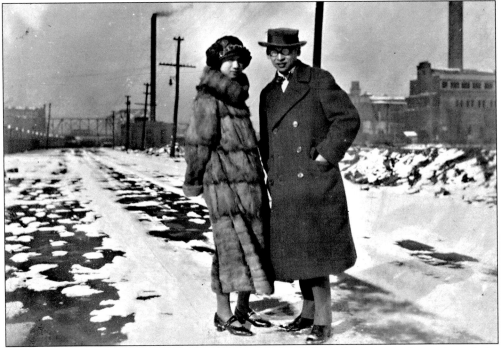

YOUNG COUPLE IN CHICAGO WINTER, 1920s. The industrial background is ugly and the couple's shoes offer no protection against the blowing snow. The two look content nonetheless. Raccoon-skin coats like hers were fashionable among young people, both women and men, in the 1920s.

YOUNG WOMAN ON BEACH, LAKE MICHIGAN, 1920S. And here is yet another pose that would have been impossibly scandalous in old China. Other photographs showed that she was with a mixed group of young men and women. That a respectable girl could allow herself to be seen acting so casually in the presence of men, and to be seen enjoying herself as well, points to a high level of Americanization.

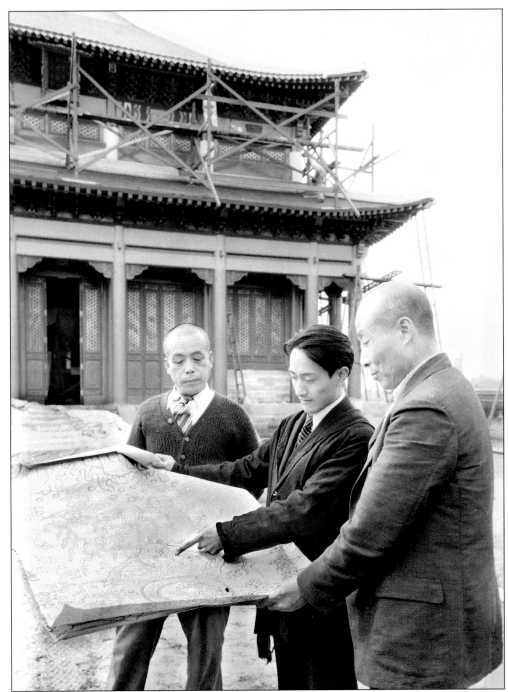

CENTURY OF PROGRESS EXPOSITION, 1933: ARCHITECTS OF THE LAMA TEMPLE. The two older men, both professional builders, came from Beijing especially to work on the temple. The younger man between them may be the Chinese Vice-Consul G. H. Wang. Wang stayed in the U.S. after the exposition and eventually left the Chinese diplomatic service to become an American citizen, a real estate developer, and a leading citizen of Chinatown. Today one block of 23rd Street west of Princeton Avenue is named after him.

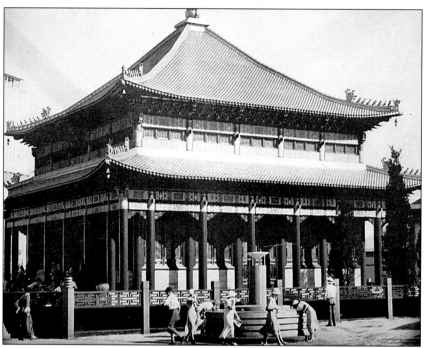

CENTURY OF PROGRESS EXPOSITION, 1933: COMPLETED LAMA TEMPLE, WITH DRINKING FOUNTAIN. The temple, which received a great deal of publicity in 1933 and 1934, was a replica of one in Jehol (now Rehe), north of Beijing. An explorer from Sweden, Sven Hedin, conceived the idea of having it made in China and shipped to Chicago, and a Swedish-American manufacturer named Bendix paid the costs. The Chinese government supported the idea strongly in spite of this Swedish connection, and at least some Chinese Chicagoans were proud that a Chinese building had become a major attraction at the exposition.

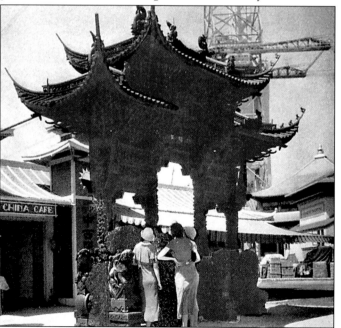

CENTURY OF PROGRESS EXPOSITION, 1933: THE CHINESE VILLAGE. China's own exhibit at the exposition was a walled area labeled a "village," with restaurants, souvenir shops, entertainment, and cultural exhibits. For earlier World Fairs, the Chinese government had brought exposition staff over from China. However, none of our sources mention the importing of staff for the 1933 Fair. It seems likely that the attendants and entertainers in the Chinese exhibits were partly local people recruited from Chinatown.

CENTURY OF PROGRESS EXPOSITION, 1933: THE VILLAGE GATEWAY. This ornamental gateway of carved teak was made in Shanghai for San Francisco's Panama-Pacific Exposition in 1915. Chicago's Field Museum bought it and eventually lent it for exhibition at the 1933 Century of Progress Exposition. Afterward it was sold to a Chicago Chinese, George M. Chan, for $1500. At that point it disappears from the historical record.

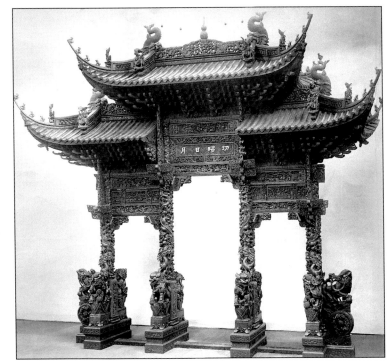

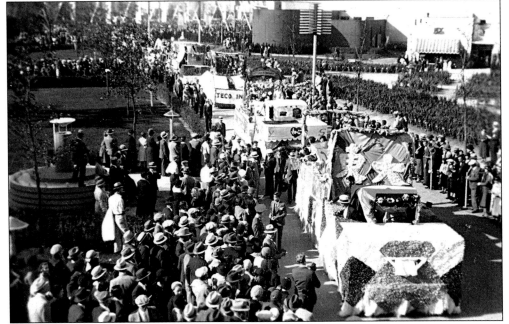

CENTURY OF PROGRESS EXPOSITION, 1933: PARADE ON AVENUE OF THE FLAGS. On October 1, the whole of Chinatown turned out for a parade through the fair to the Lama Temple and Chinese Village. With floats, bands, boy scouts, and pretty girls in Chinese costume, the parade was a great success. It was also the first time that the full Chinese community of Chicago had asserted itself as the equal of every other ethnic community, parading in front of other Chicagoans and visitors from the entire world.

MEDALS FROM A CHINESE CIVIL RIGHTS ORGANIZATION. The organization was founded in San Francisco in the 1890s under the name "Native Sons of the Golden State," a play on the name of the virulently racist Native Sons of the Golden West that had sponsored many local anti-Chinese laws. The goal of the NSGS was opposite that of the NSGW: to fight for racial justice and equality. Perhaps because the name was confusing and to emphasize its national scope, in the early 1900s, the NSGS changed its name to the Chinese American Citizens' Alliance or NACA. The NSGW still exists, though now it promotes Californian history rather than Caucasian racial purity.

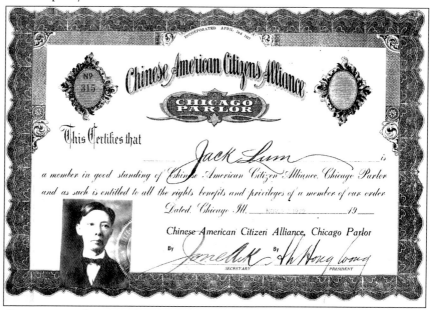

MEMBERSHIP CERTIFICATE, CHINESE AMERICAN CITIZENS' ALLIANCE, 1922. This belonged to Jack Lum, a Springfield restaurant owner. At the time NACA was still active in working for Chinese-American rights. Due to the danger of being caught and deported by the Immigration Bureau, membership had to be restricted to those who were citizens because they or their fathers had been born in the U.S. The organizations may have lost focus in the 1930s, however. Later documents belonging to Lum show that NACA in the 1930s was becoming involved with business deals and credit union activities.

BIG BROTHER GOES OFF TO WAR, 1943. The soldier is Charlie Toy, of Chicago and Michigan's Benton Harbor. Like many other Chinese Americans he joined the army to fight not only the Japanese as attackers of China but all of the Axis powers (Germany, Italy, and Japan) as enemies of America. Charlie was captured by the German army in Europe. His family and friends back home, who had thought he was dead, were overjoyed to hear he was a POW. He was released from the prison camp in 1945, an American hero. The experience of facing a common enemy broke down many racial barriers. Older Chinese Americans say that World War II was the first time that they began to feel accepted as real Americans.

SOLDIERS IN A JEEP, 1943–4. The American army did not have segregated Chinese-only units during World War II. Chinese Americans fought, and sometimes died, side-by-side with their European-American comrades.

REFERENCES

Cao, Lan, and Himilee Novas. *Everything You Need to Know About Asian-American History.* New York: Plume/Penguin, 1996.

Chang, Iris. *The Chinese in America.* New York: Penguin Books, 2003.

Chih, Ginger and Diane Lin Mei Mark. *A Place Called Chinese America.* Dubuque: Kendall Hunt Publishing Company, 1982.

Chinn, Thomas W. *Bridging the Pacific, San Francisco Chinatown and its People.* San Francisco: Chinese Historical Society of America, 1989.

Chiou, Yin Hsiu-Wen, editor. *A Century of Chicago Chinatown.* Chicago: Chinese Consolidated Benevolent Association of Chicago, 2000.

Chow, Lily. *Sojourners in the North.* Prince George, B.C.: Caitlin Press, 1996.

Christoff, Peggy Spitzer. *Tacking the "Yellow Peril" The INS and Chinese Immigrants in the Midwest.* Rockport: Picton Press, 2001.

Fan, Tin-Chiu. *Chinese Residents in Chicago.* Dissertation for the University of Chicago, 1926. Reprint, editor A. Eterovich. Saratoga: R and E Research Associates, 1974.

Lai, Him Mark, Genny Lim, and Judy Yung. *Island, Poetry and History of Chinese Immigrants on Angel Island 1910–1940.* San Francisco: Hoi Doi, 1986.

Lee, Rose Hum. *The Chinese in the United States of America.* Hong Kong: Hong Kong University Press, 1960.

Lindberg, Richard. "Chinese Chicago." *Ethnic Chicago, A Complete Guide to the Many Faces and Cultures of Chicago*: 286-305. Lincolnwood, Illinois: Passport Books, 1993.

Ling, Lew, editor. *The Chinese in North America, a Guide to Their Life and Progress.* Los Angeles: East-West Culture Publishing Association, 1949.

Lum, Raynond. "Life and Times of Early Chinese in Southern Illinois." *Bridge, an Asian American Perspective* 5(2) (summer 1977): 30-34.

McCunn, Ruthanne Lum. *An Illustrated History of the Chinese in America.* San Francisco: Design Enterprises of San Francisco, 1979.

McCunn, Ruthanne Lum. *Chinese American Portraits, Personal Histories 1828–1988.* Seattle and London: University of Washington Press, 1988.

McNulty, Elizabeth. *Chicago Then and Now.* San Diego: Thunder Bay Press, 2000.

Moy Family Association, editor. *History of the Moy Clan and Family Association* [Meishi zongqin zubu]. Taipei: Xielian yinshuguan, 1991. Reprint, 2001.

Moy, Susan Lee. "The Chinese in Chicago: The First One Hundred Years." *Ethnic Chicago, A Multicultural Portrait.* Grand Rapids: William B. Eerdmans Publishing Company, 1995.

Pan, Lynn. *Sons of the Yellow Emperor, The Story of the Overseas Chinese.* London: Secker & Warburg, 1990.

Pan, Lynn, editor. *Encyclopedia of the Chinese Overseas.* Singapore: Archipelago Press/ Landmark Books, 1998.

St. Therese Parish and St. Therese School. *The History of Santa Maria Incoronata & St. Therese Chinese Mission 1904–2004.* Chicago: St. Therese Parish, 2005.

Saxton, Alexander. *The Indespensable Enemy.* Berkeley: University of California Press, 1971.

Sit, Elaine. "Chinese Put Down Roots." *20th Century Chicago, 100 Years, 100 Voices.* Chicago: Chicago Sun-Times, 2000.

Sui, Paul C.P. *The Chinese Laundryman: A Study of Social Isolation.* Edited by John Kuo-wei. New York: New York University Press, 1987.

Takaki, Ronald. *Journey to Gold Mountain, The Chinese in 19th-Century America.* New York: Chelsea House Publishers, 1994.

Tan, Thomas Tsu-wee. *Your Chinese Roots, The Overseas Chinese Story*. Singapore: Times Editions Pte. Ltd., 1986.

Wilson, Margaret Gibbons. *Concentration and Dispersion of the Chinese Population of Chicago 1870–1960*. M.A. thesis. Chicago: University of Chicago, 1969.

Wong, K. Scott and Sucheng Chan, editors. *Claiming America, Constructing Chinese American Identities During the Exclusion Era*. Philadelphia: Temple University Press, 1998.

Wu, Tingfang. *America Through the Spectacles of an Oriental Diplomat*. University of Oregon, 1914. http://e-asia.uoregon.edu.

INDEX